IMAGES
of America

CEMETERIES OF
SANTA CLARA

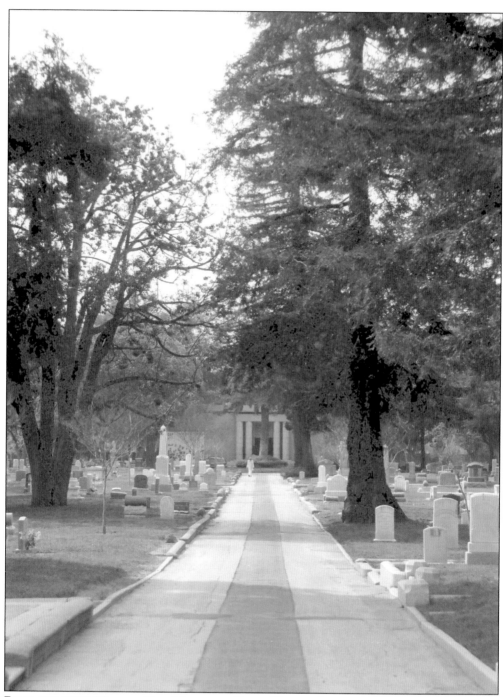

ROAD THROUGH MISSION CITY MEMORIAL PARK. This road invites visitors into the cemetery. History is brought to life through the wonderful monuments and markers here. (Courtesy Dave Monley Photography.)

ON THE COVER: This photograph of the Arguello Monument at Santa Clara Mission Cemetery was taken by Dave Monley of San Jose, California. (Courtesy Dave Monley Photography.)

IMAGES
of America

CEMETERIES OF
SANTA CLARA

Bea Lichtenstein

ARCADIA
PUBLISHING

Published by Arcadia Publishing
Charleston, South Carolina

Printed in the United States of America

Library of Congress Catalog Card Number: 2005929094

For all general information contact Arcadia Publishing at:
Telephone 843-853-2070
Fax 843-853-0044
E-mail sales@arcadiapublishing.com
For customer service and orders:
Toll-Free 1-888-313-2665

Visit us on the Internet at www.arcadiapublishing.com

CONTENTS

ACKNOWLEDGMENTS

Without the outstanding visual contributions of my friend, San Jose photographer Dave Monley, this book would not have the visual impact it now does. I am deeply indebted to him.

Other major contributors include Larry De Janvier at Mission City Memorial Park and Don Sylva, Loretta, Mary Lou, and Mike at Santa Clara Mission Cemetery. They have patiently answered questions and provided a variety of information.

The Santa City Library Heritage Pavilion, headed by local history librarian Mary Hanel, has provided photographs and other services. David Smith, library graphic artist, scanned images from a variety of resource materials. The scanned images were burned onto CDs by Angie Vincent of the library's automation department, and headstone translations were contributed by Jenny Hsiao, Peyman Naghshineh, and Huong Nguy.

Special thanks are owed to artist Jim Johnson and Heidi Garland of Guild West for creating the fabulous tour maps of the cemeteries.

This publication wouldn't exist without the people and organizations that provided photographs and illustrations:

Lois Brown
Buchser family
Don Callejon
Margie (Toledo) Del Prete
Michele (Gomez) Barovsky
Mary (Sanchez) Gomez
Peg Horrillo
Mrs. Irene Inman
Margaret Jenkins
Judge Mark Thomas

California History Center, DeAnza College
Santa Clara Historic Archives
Santa Clara Unified School District
Santa Clara University Archives
Warburton family
Wilson family
Margot (Blake) Warburton
Rose (Navarro) Penner
Isabel (Navarro) Steffan

Special thanks to my friends and family, especially my husband, Ken. They provided encouragement and support during the process of creating this publication.

Finally, a special thanks to my editor, Hannah Clayborn, for her help and support, plus Arcadia Publishing for giving me the opportunity to create this second book for their Images of America series.

Part I

MISSION CITY
MEMORIAL PARK

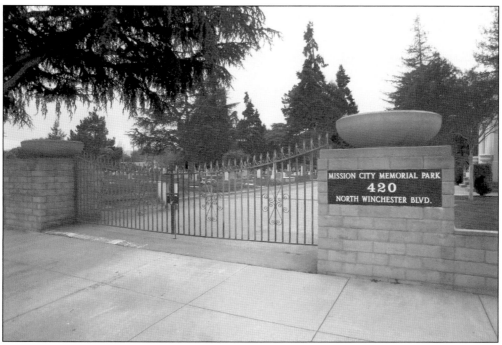

MISSION CITY MEMORIAL PARK GATE. This wall and gate replaced the original fence when Winchester Boulevard was widened in 1973. The widening necessitated moving a row of graves in order to accommodate the new fence and sidewalk. (Courtesy Dave Monley Photography.)

INTRODUCTION

The rich history of Santa Clara and Santa Clara Valley dates back to the arrival of Spanish explorers. Capt. Gaspar de Portolá and his party became the first Europeans in the area in November 1769. The Spanish laid claim to the land by establishing a string of 22 churches or missions, which stretched from San Diego to Sonoma. The eighth of these missions, founded January 12, 1777, was Mission Santa Clara, named for St. Clare of Assisi.

Mexican independence from Spain in 1821 brought new rule to the missions in California. In 1836, the founding Franciscan fathers lost control of Mission Santa Clara through the process of secularization. Civil commissioners were to oversee the return of the land to the native population. This did not happen and squatters took over the church buildings and lands. Disorder and decay ensued.

In the 1840s, the American frontier expanded west to California and new settlers arrived in the area. These first overland parties included the Stephens-Townsend-Murphy and the Reed-Donner parties, who settled in the area of Santa Clara. In 1846, America took control of California.

The discovery of gold in 1848 brought a huge influx of people of many ethnic backgrounds. During the gold rush, the promise of great wealth failed to materialize for most gold seekers, so they turned to the black gold that was the fertile soil of Santa Clara Valley.

In the 1850s, Santa Clara began to take shape as a small town. A schoolhouse, several Protestant churches, hotels, and stores were erected. Established on the old mission site in 1851, Santa Clara College became a prominent feature of the developing locale. Santa Clara incorporated as a town in 1852 and became state chartered in 1862.

As the early pioneers eventually died, many were buried in Santa Clara's two cemeteries; the Protestant or City Cemetery and the Catholic cemetery. The city-owned cemetery is now called Mission City Memorial Park and the Catholic cemetery is called Santa Clara Mission Cemetery. Cemeteries serve as final resting places for our loved ones, but they are also places of historical significance that provide a fascinating look into the past and the people who helped shape it.

A WALK THROUGH HISTORY

The original cemetery is estimated to have been 300 foot square, equaling about two acres of land. Purchased by the town's first board of trustees in 1850–1851, it was called "the graveyard" and later, Town of Santa Clara Cemetery, then Santa Clara City Cemetery, Santa Clara Protestant Cemetery and, since 1972, Mission City Memorial Park.

An early deed that added land to the cemetery grounds included a provision that a portion of this land be used for boarding escaped animals. Stray and roaming swine, sheep, goats, cows, and horses were taken there to be claimed by owners or sold at auction. The site also served as the town dumping grounds as well.

In July 1862, rules and ordinances for the operation of this cemetery—including plot prices, establishment of a Sexton for burial supervision, and the requirement that plot records be kept—were established. The ordinances stated that persons not owning burial lots could not bury their dead except in the public grounds (the "potter's field") of the cemetery. Plots in 1873 cost $20 to $25. Burial in the public grounds (potter's field) cost $5 and sometimes less, if the indigent being buried received no headstone or marker.

The first recorded interment, of Walter S. McDonald, was on September 13, 1864. There were, perhaps earlier books and records of cemetery affairs prior to 1864, but what has become of them is unknown. The records that remain, however, show improvements being authorized for the cemetery grounds including planting of trees, grading of two main roads in the cemetery, and installation of fences and other amenities.

Another regulation, enacted in 1872, required that the sexton/superintendent refuse to bury anyone until a death certificate was furnished to him by a proper authority.

Over the years, Mission City Memorial Park has continued to add features and sections and to improve on the amenities that are available. Thirty years after the Indoor Mausoleum was built in 1938, a garden-type mausoleum was constructed. Other special areas include Babyland and the Children's Gardens sections, plus special sections for Greek, Chinese, Farsi, Vietnamese, and other foreign-language monuments.

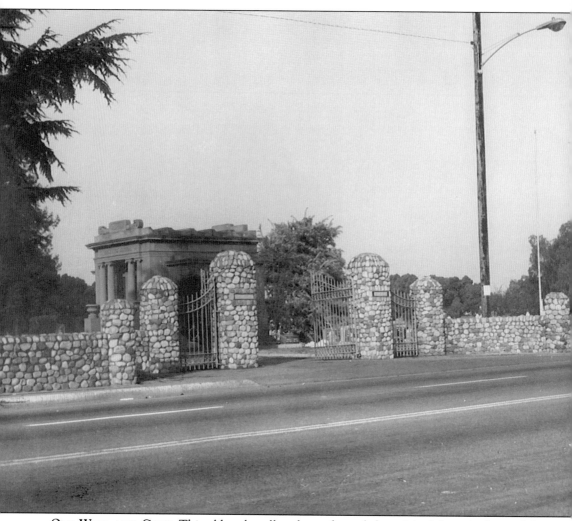

OLD WALL AND GATE. This old rock wall and gate formed the original fence in front of the Mission City Memorial Park. Its exact construction date is unknown, and the present wall and gate replaced it in 1973. This is the same type of rock that surrounds the Sarah Fox and Frederick Christian Franck grave sites. (Courtesy Mission City Memorial Park.)

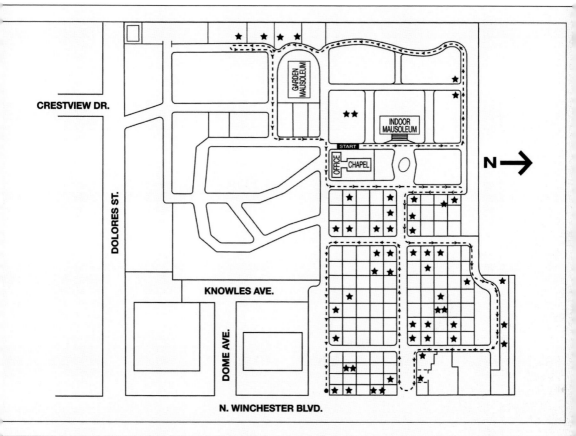

MISSION CITY MEMORIAL PARK TOUR MAP. Use this map as a guide to learn about selected people buried in Mission City Memorial Park. Start at the two starred sites near the office and follow the arrows for your tour. (Courtesy Guild West.)

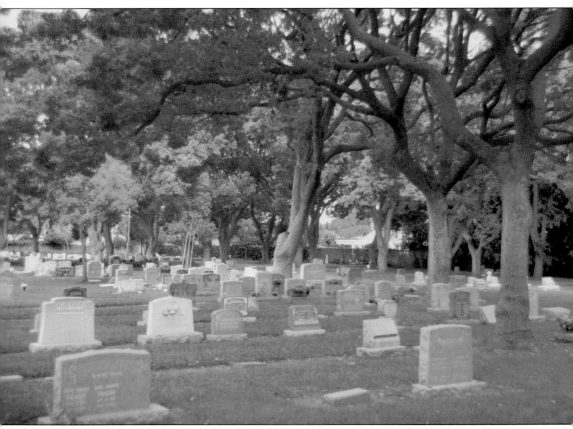

PEACEFUL SETTING. This peaceful panorama invites visitors to walk through the monuments and markers to discover the identities of the people who are at rest in this serene environment. (Courtesy Dave Monley Photography.)

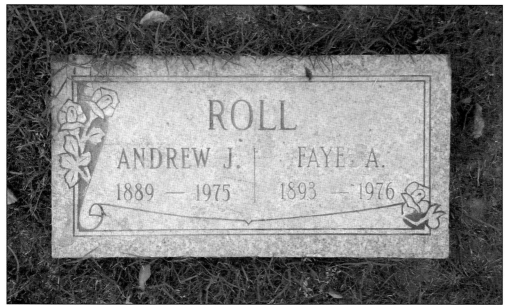

ANDREW JOHN (1889–1975) AND FAYE (1893–1976) ROLL MARKER. Andrew J. "Andy" Roll was born in Santa Clara, the son of Robert B. and Louise Roll and the nephew of John Roll. He attended local schools until age 15, when he left to work in the family business, Enterprise Steam Laundry. Andy was active in many organizations such as the Native Sons of the Golden West and other fraternal orders. He also served as a city trustee from 1931 to 1937. (Courtesy Dave Monley Photography.)

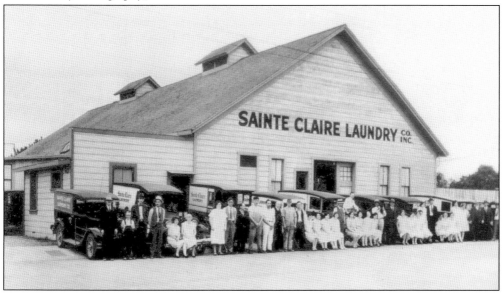

SAINTE CLAIRE LAUNDRY. In 1904, Andy Roll started work at the Enterprise Steam Laundry. Enterprise Steam Laundry became Saint Claire Laundry Incorporated in 1927 under the ownership of the Strickland brothers. After partnering with the Strickland's for a time, Andy assumed sole ownership of the business in 1935 and continued to operate it until it finally closed in 1970. Santa Clara University later used the site to expand its campus. (Courtesy Santa Clara City Library, Leonard McKay's Clyde Arbuckle Collection.)

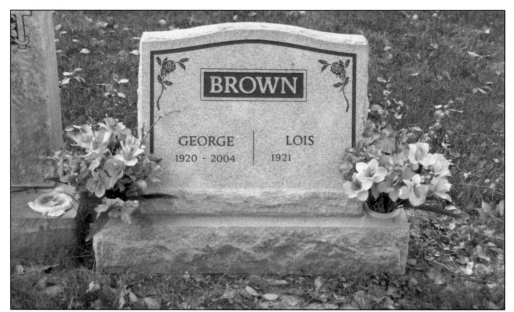

GEORGE M. BROWN MONUMENT. A native Santa Claran, George (1920–2004) was the son of Walter G. and Isabel Brown and the grandson of George Miller Brown who emigrated from England and started a pear and strawberry ranch in the Santa Clara area in 1868. George attended Jefferson Union School and Santa Clara High and then went to the University of California, Davis and studied horticulture. (Courtesy Dave Monley Photography.)

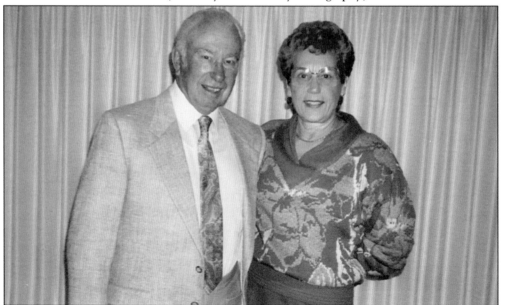

GEORGE M. AND LOIS BROWN. George served as a captain in the U.S. Army Air Corps during World War II, flying fighters in the South Pacific. While in the service, on July 1, 1944, he married his high school sweetheart, Lois Jean Silver. George was a leader locally and statewide, both in the agriculture industry and in serving his community. He served on the Jefferson Union School Board of Trustees, the Santa Clara Rotary, and the Santa Clara Masonic lodge. (Courtesy Lois Brown.)

INDOOR MAUSOLEUM. The Indoor Mausoleum was built in 1938. Note the bronze doors and stained glass that reflect the architectural style popular at that time. Many prominent Santa Clara residents are at rest here, including Ora Lee Hirsch Merritt, Dr. Judson Waldo Paul, John Widney, and members of the Wilson's Jewel Bakery family. (Courtesy Dave Monley Photography.)

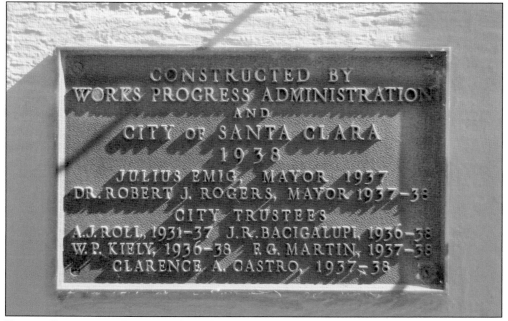

BRONZE DEDICATION PLAQUE. The Indoor Mausoleum was built as a WPA project in 1938. This plaque, located on the right wall next to the bronze entry doors, notes that the construction was a collaborative effort of the Works Progress Administration (WPA) and the City of Santa Clara. (Courtesy Dave Monley Photography.)

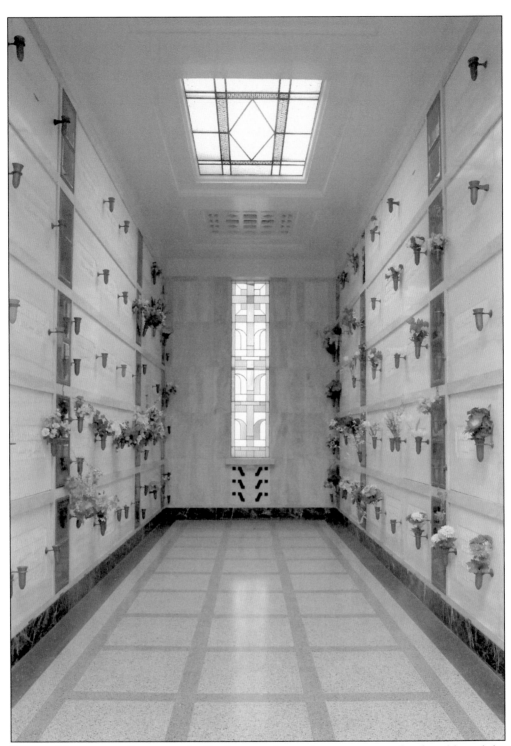

INDOOR MAUSOLEUM INTERIOR. Inside the mausoleum, the crypts are made of marble and the floors are made of a material similar to marble. There are stained glass windows on each wall of the east and west wings and three stained-glass skylights in the ceiling. (Courtesy Dave Monley Photography.)

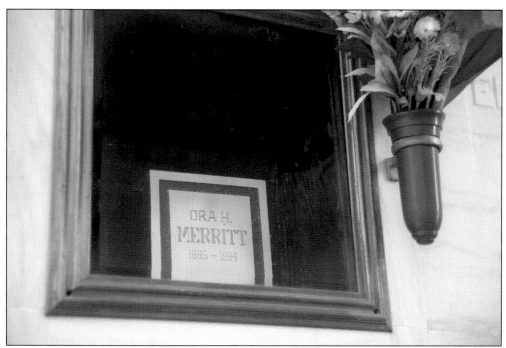

ORA LEE HIRSCH MERRITT NICHE.
Ora Lee (1895–1984), a Santa Clara
native, was the daughter of Emil and
Emma Hirsch who started Santa Clara
Undertaking Company. Ora graduated
from Santa Clara High School and then
enlisted in the Navy. After returning
to civilian life, she married Theodore
Merritt, raised her daughter Ruth,
obtained a teaching credential from San
Jose State University, and taught for 30
years before retiring in 1964. (Courtesy
Dave Monley Photography.)

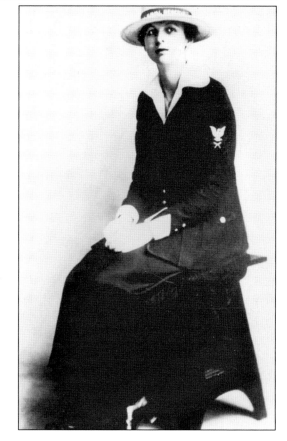

YEOMAN ORA LEE HIRSCH. Ora became
one of few women to enlist in the military
during World War I and serve in a
capacity other than nursing. Yeoman F.
Hirsch lived in San Francisco and took a
boat from the pier to "Goat Island" (now
Treasure Island) where she worked in the
Intelligence Office, decoding messages.
In 1947, she was elected American Legion
department vice commander for women
in California. (Courtesy Ruth [Merritt]
Landon, Bea Lichtenstein collection.)

DR. JUDSON WALDO AND MARION P. PAUL HOUSE. Judson (1861–1937) was born in Ohio and attended DePaw University at Greencastle, Indiana, before earning his medical degree from Bellevue Hospital in 1891 at the Medical College in New York. After a few years as a house surgeon and clinical physician on the East Coast, Judson came to California in 1894 to establish his own practice. He became a well-known and respected physician in Santa Clara. (Courtesy Clarence R. Tower.)

DR. JUDSON WALDO PAUL. Judson married Marion Louise Powell (1873–1937) in Alameda County. Marion had two daughters from a previous marriage and two sons were born to the second marriage. Fraternally, Dr. Paul affiliated with the Oddfellows, Improved Order of Red Men, and the Independent Order of Foresters. In 1897, the Paul's built an Eastlake-style home on the corner of Washington and Benton Streets, which still stands today. Judson used the house for his practice as well as his residence. (Courtesy Santa Clara City Library from *Progressive Santa Clara*, 1904.)

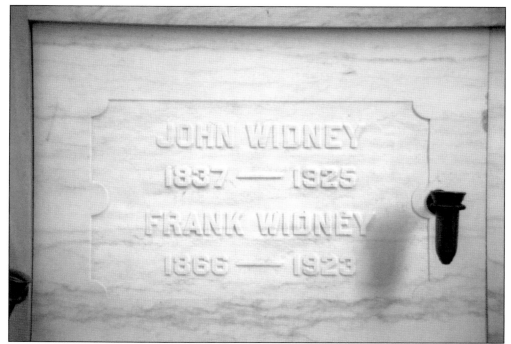

JOHN WIDNEY CRYPT. Born in Ohio, John (1837–1925) came to California with his parents at an early age. Widney became active in community affairs, serving as a trustee and president of the Santa Clara Town Board of Trustees before the town incorporated in 1852. He was elected as the first treasurer for the Town of Santa Clara and was reelected from 1866 to 1869. He served as trustee of the College of the Pacific as well as trustee and steward of the Methodist Church. (Courtesy Dave Monley Photography.)

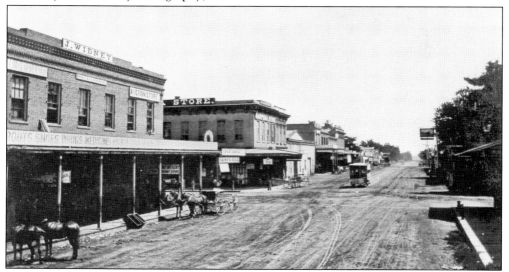

WIDNEY'S MERCANTILE. John started and operated several businesses, including a grocery store, a plumbing business, and Santa Clara's first telegraph office, the Postal Telegraph. John Widney opened his store, Widney's Mercantile, on the corner of Franklin and Main Streets in 1857 and continued to operate that business for 30 years until he retired from mercantile life and engaged in real estate enterprises. (Courtesy Santa Clara Historic Archives.)

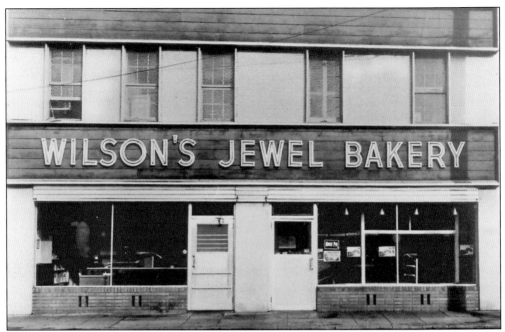

WILSON'S JEWEL BAKERY. William A. "Bill" Wilson bought the Jewel Bakery at 1151 Franklin Street in 1921 and named it Wilson's Jewel Bakery. The business prospered and gained a valley-wide reputation over the years. When the 1960s urban renewal project razed eight square blocks of downtown Santa Clara, Wilson's Jewel Bakery was among 13 original property owners who relocated to the Franklin Mall development. The bakery is now operated by Alex and Ken Wilson and their mother, Rosalie. (Courtesy Wilson family.)

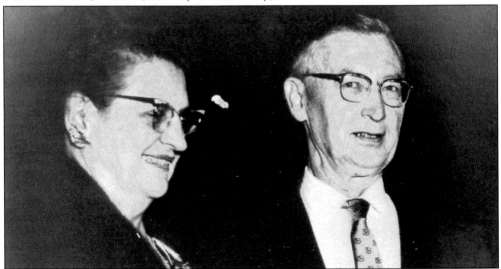

WILLIAM A. AND URSULA WILSON. Bill Wilson Sr. dedicated over 30 years of his life to Santa Clara schools, serving on both elementary and high school boards as well as the Santa Clara Unified Boards of Education. He was a member of the Masons, Oddfellows, American Legion Post 419, and a charter member of the Santa Clara Rotary Club. Ursula was a 30-year member of the Red Cross, president of the Santa Clara Woman's Club, Chapter 196 OES and Rebekkah Lodge No. 34. (Courtesy Wilson family.)

WILLIAM A. WILSON JR. Bill Jr. followed in the Wilson family tradition of service to the community, serving four years on the city council (1963–1967), one year (1965–1966) as mayor, and another four years on the city council. He also served on the Triton Museum Board of Directors. Through his efforts, the Bill Wilson Center was established in Santa Clara, serving the youth of the area. His community service was cut short by his death at age 42. (Courtesy Wilson family.)

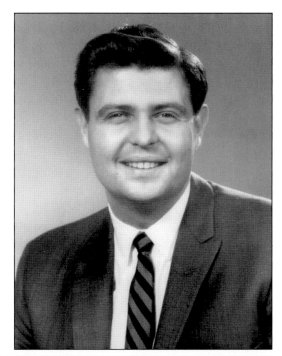

WILSON'S JEWEL BAKERY. William A. (Bill) Wilson bought the Jewel Bakery at 1151 Franklin Street in 1921 and named it Wilson's Jewel Bakery. The business prospered and gained a valley-wide reputation over the years. When the 1960s Urban Renewal Project razed eight square blocks of downtown Santa Clara, Wilson's Jewel Bakery was among 13 original property owners who relocated to Franklin Mall. The bakery is now operated by (from left to right) Alex, Rosalie, and Ken Wilson. (Courtesy Wilson family.)

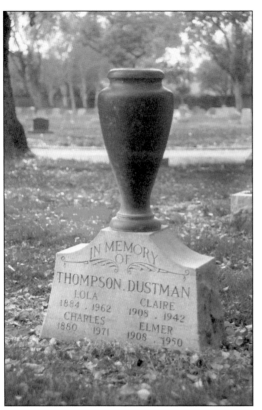

CHARLES L. (1880–1971) AND LOLA (1884–1962) THOMPSON MONUMENT. Charles was a native of Santa Clara who graduated from Santa Clara College and was an active member of the Native Sons of the Golden West. In 1927, as statewide president of that group, he laid the cornerstone of the Los Angeles City Hall. His father, Isaac Thompson, was one of Santa Clara's most prominent early settlers who crossed the plains from Ohio to California by ox-drawn wagon in 1849. (Courtesy Dave Monley Photography.)

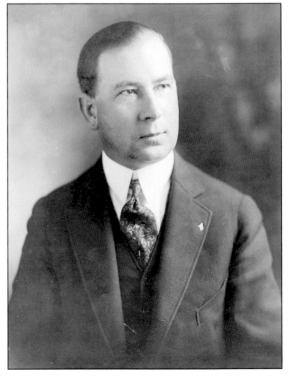

CHARLES L. THOMPSON. Thompson was elected treasurer of Santa Clara for a two-year term and served as a Santa Clara justice of the peace and judge for a total of 47 years while also maintaining a private law practice. He was active in the community and served as president of at least a dozen organizations during his lifetime. (Courtesy Judge Mark Thomas.)

VETERANS SECTION. The Veterans section of Memorial Park is dedicated to the brave men and women who served in the Civil War, Spanish-American War, World War I, World War II, the Korean Conflict, and the Vietnam War. American Legion Post 419 of Santa Clara donated the monument. (Courtesy Dave Monley Photography.)

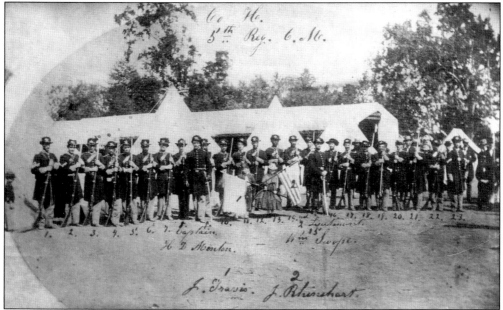

SANTA CLARA CIVIL WAR UNIT. The members of Santa Clara Company H, 5th Regiment, gather with Capt. H. L. Menton and Lieutenant Swope. The children holding the flags in the center front are J. Travis and J. Rheinhart. The Santa Clara Tannery supplied leather used in saddles, harnesses, and shoes during the Civil War. (Courtesy Santa Clara Historic Archives.)

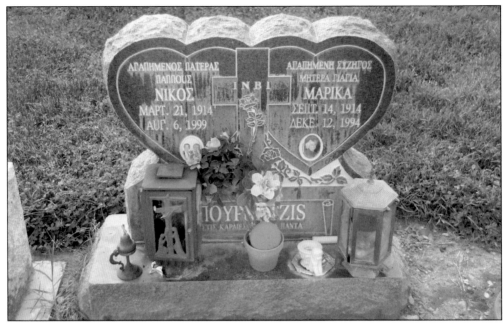

GREEK MONUMENT. The Greek letters here commemorate Agapnmenoz Pateraz Pappouz Nikoz (left), born March 21, 1914, and died August 6, 1999, and Agapmenn Zuzngoz Mntera Giagia Marika (right), born September 14, 1914, and died December 12, 1994. An annual Greek festival celeberates the Hellenic traditions of the Greek community in Santa Clara Valley. (Courtesy Dave Monley Photography.)

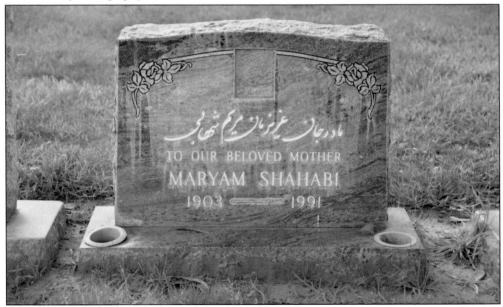

FARSI MONUMENT. Farsi is a member of the Indo-Iranian family of languages and is the official language of Iran. The Farsi inscription on this headstone is translated as "Our Dearest Mother," which is roughly equivalent to the English version. Many of the Persian/Iranian community in Silicon Valley are professionals, and 40 percent operate their own businesses.(Courtesy Dave Monley Photography.)

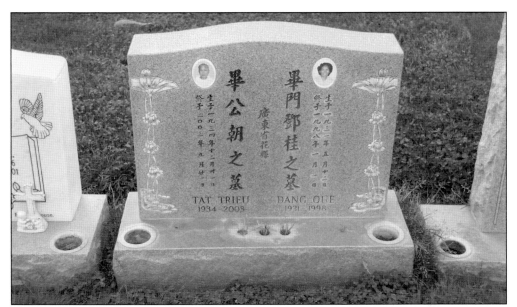

CHINESE MONUMENT. The monument is in Cantonese. The last name (the topmost characters between the pictures) is Bat. Tat Trieu is the man and the characters indicate the birth date by year first, month second, and day third: "1934.12.31–2003.9.31" is December 31, 1934, to August 31, 2003. Dang Que is the woman, and "1931.5.12–1998.1.1" is May 12, 1931, to January 1, 1998. (Courtesy Dave Monley Photography.)

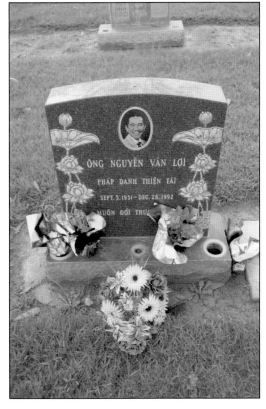

VIETNAMESE MARKER. This beautiful monument honors Mr. Loi Van Nguyen whose picture is featured in the center. His Buddhist name is Thein Tai. He was born September 3, 1931, and died December 28, 1992. The inscription at the bottom translates "Loved and Remembered Forever." Many Santa Claran Vietnamese who fled Vietnam after the fall of Saigon in 1975 are involved in high-tech enterprises. (Courtesy Dave Monley Photography.)

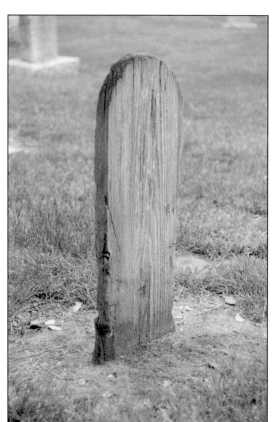

1906 EARTHQUAKE WOODEN MARKER. The only two wooden headstones still in existence in Mission City Memorial Park date back to the 1906 San Francisco earthquake. The most severe earthquake damage in the valley was experienced at the Agnews Asylum for the Insane, where it was reported that 112 patients and staff were killed when several four-story brick buildings collapsed. (Courtesy Dave Monley Photography.)

AGNEWS ASYLUM FOR THE INSANE. Agnews Asylum for the Insane opened in 1886 for the treatment of the mentally ill. The facility of four- and five-story brick buildings first housed 65 patients from the Stockton Insane Asylum. By the earthquake of April 18, 1906, there were 1,800 occupants. Many survivors were moved temporarily to Stockton, but over 860 were housed in tents and temporary structures while the facility was rebuilt. (Courtesy Santa Clara City Library, Alice Hare Collection.)

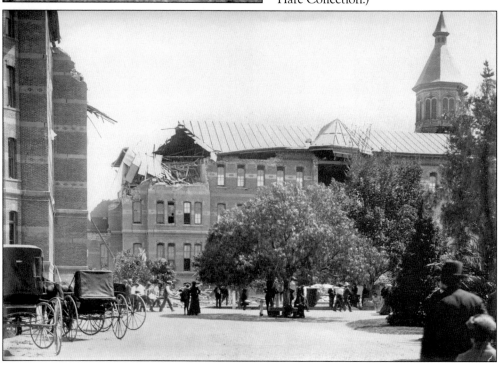

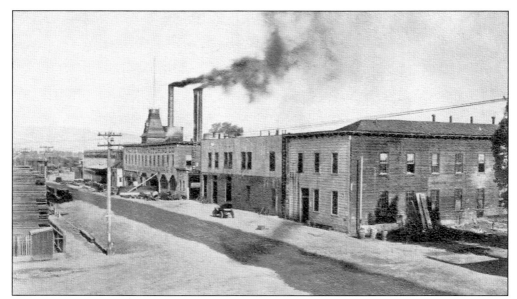

PACIFIC MANUFACTURING COMPANY. James Pierce bought Enterprise Mill and Lumber Company in Santa Clara in 1874. Pierce changed the name to Pacific Manufacturing Company when the business incorporated in 1879. (Courtesy Santa Clara Historic Archives.)

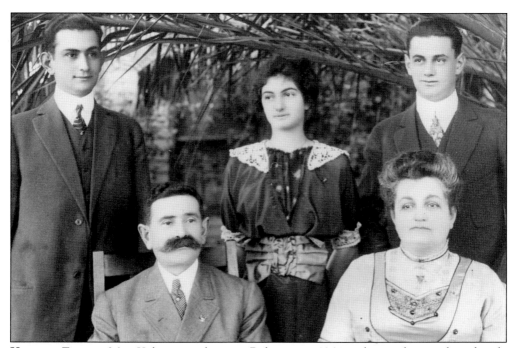

KOHNER FAMILY. Max Kohner was born in Bohemia in 1864 and spent his youth and early manhood years there. After his marriage in 1891 to Carla (1870–1934), they came to America and settled in Santa Clara. Their children included Rose (1892 –1922), who married Dr. Louis Rose; Oscar (1893–1929); and Arthur (1895–1950). The whole family—plus Arthur's wife, Barbara, and Oscar's wife, Harriet—are buried in the Kohner family plot. (Courtesy Marjorie Winters, daughter of Dr. Louis and Rose Kohner Rose.)

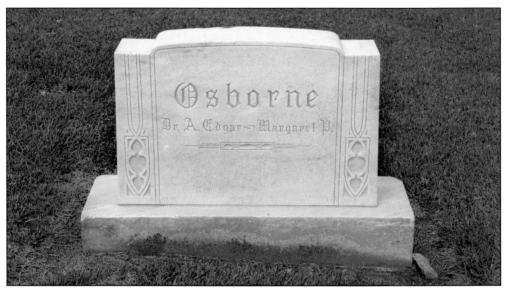

DR. ANTRIM EDGAR AND MARGARET OSBORNE MONUMENT. Antrim Edgar (1856–1935) was born in Pennsylvania and earned many educational degrees including an M.D. and Ph.D. from the University of Pennsylvania. He came to Santa Clara in 1866, as superintendent of the California Home for the Care and Training of the Feebleminded where he served for 15 years. This facility finally moved to Sonoma and became a State Hospital for the Feebleminded. (Courtesy Dave Monley Photography.)

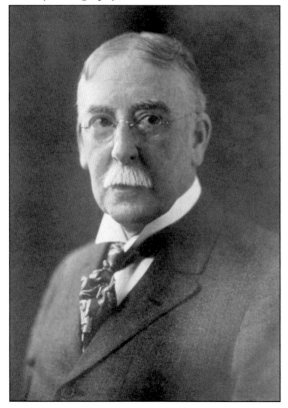

DR. ANTRIM EDGAR OSBORNE. Dr. Osborne was active in the California Medical Society and twice president of the Santa Clara County Medical Society. Fraternally he was a member of the Odd Fellows, the Knights of Columbus, and several branches of the Masonic Order. He helped build the Scottish Rite Temple in San Jose. (Courtesy Santa Clara City Library from *History of Santa Clara County, California* by Eugene Sawyer, 1922.)

MARGARET P. OSBORNE. In March 1904, Margaret (1850–1944) presided over the first meeting called to form a civic improvement society that became known as the Santa Clara Woman's Club. She was also involved with the Federation of Women's Club and vice president of the San Francisco District of Federated Clubs. Margaret, one of 11 charter members, served as the Santa Clara Woman's Club's first president from 1904 to 1912 and then again from 1916 to 1935. (Courtesy Santa Clara Woman's Club Archives.)

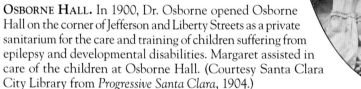

OSBORNE HALL. In 1900, Dr. Osborne opened Osborne Hall on the corner of Jefferson and Liberty Streets as a private sanitarium for the care and training of children suffering from epilepsy and developmental disabilities. Margaret assisted in the care of the children at Osborne Hall. (Courtesy Santa Clara City Library from *Progressive Santa Clara*, 1904.)

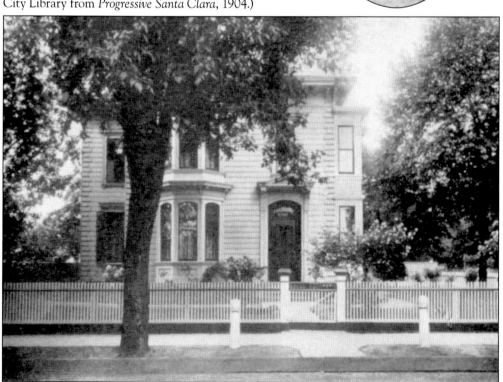

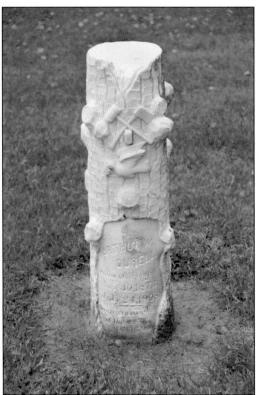

TREE STUMP MONUMENT. This unusual monument is for Arthur Durell, who was born November 30, 1879, and died July 24, 1908. Note the elaborate design on the tree stump with flowers, a wooden mallet, hatchet, and dove carved into the piece. The writing at the bottom notes that Arthur Durell was associated with the Woodmen of the World fraternal group. (Courtesy Dave Monley Photography.)

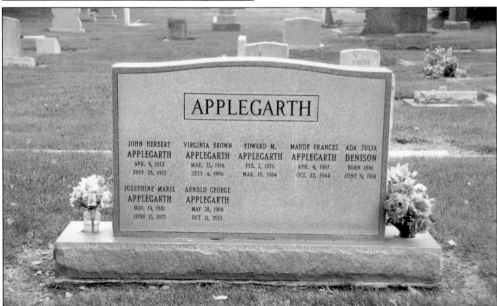

MABEL MAUDE AND MAUDE FRANCES APPLEGARTH MONUMENT. Mabel Maude (1873–1915) and Maude Frances (1867–1944) share the same last name and resting place, but they were sisters-in-laws, not sisters. Maude Frances was married to Edward M. Applegarth, the brother of Mabel Maude. Mabel Maude was a close friend of Jack London and reputed to be the inspiration for the character Ruth Morse in London's novel *Martin Eden*. (Courtesy Dave Monley Photography.)

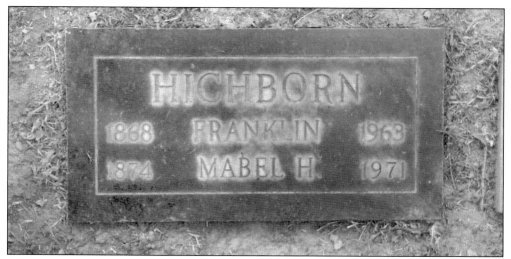

FRANKLIN AND MABEL H. HICHBORN MARKER. A descendant of Paul Revere and a native Californian born in Eureka, Franklin (1868–1963) gained national recognition for his work as an investigative journalist and reformer. He began his career in Sacramento, first working as reporter for the *San Francisco Examiner*, later working for the *Sacramento Bee*, *Stockton Record*, and *San Francisco Chronicle*. He was editor of the weekly *Spectator* in San Jose and later served as city editor of the old *Herald*, a predecessor of the *Mercury*. (Courtesy Dave Monley Photography.)

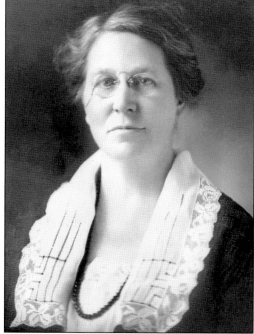

FRANKLIN AND MABEL HICHBORN. Franklin married Mabel Houlton (1874–1971) on December 31, 1897. They had five children: Paul Revere (1898–1961), Deborah M. (1900–), Drusilla Ruth (1904–2004), and twins, Frances M. and Mabel H. (1907–1921). The family lived at 1091 Fremont Street in a home built in 1865 by Santa Clara pioneer Cary Peebels. The landmark property is called the Peebels-Hichborn house. (Courtesy California History Center, De Anza College, Cupertino.)

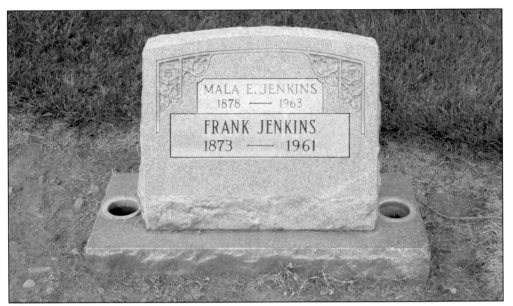

Frank (1873–1961) and Mala Etta (1878–1936) Jenkins Monument. Frank was born in Mountain View on the site of what is now Moffett Field. He became a fruit rancher on Pruneridge Avenue land, in the vicinity of today's Saratoga Avenue and Winchester Boulevard. Frank later operated a grocery store on Franklin Street for many years. (Courtesy Dave Monley Photography.)

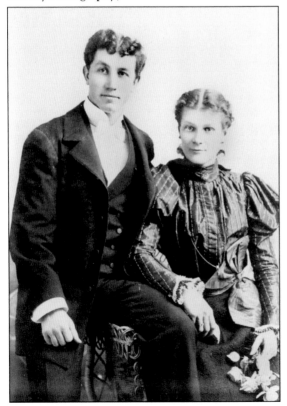

Frank and Mala Etta Jenkins. Frank married Mala Etta Helm on September 8, 1896, in Santa Clara. Mala was an avid bicyclist who would ride to San Francisco and back for a day of shopping. This was not a common or accepted thing for women at that time. Mala was also a member of the Garden City Cyclists. Her two daughters, Sarah and Margaret, were involved in sports, playing softball at Santa Clara High. (Courtesy Margaret Jenkins, Bea Lichtenstein collection.)

MARGARET JENKINS. Margaret (1903–1996) graduated from Santa Clara High in 1921 and from San Jose State College in 1925. Margaret, followed in her mother's athletic footsteps, excelling in many sports and paving the way for women in the sports arena. She became the first woman from Santa Clara County to participate in track and field in the Olympics in 1928. Margaret is pictured in her 1928 Olympics uniform with her friend Eric Krenz. (Courtesy Margaret Jenkins, Bea Lichtenstein collection.)

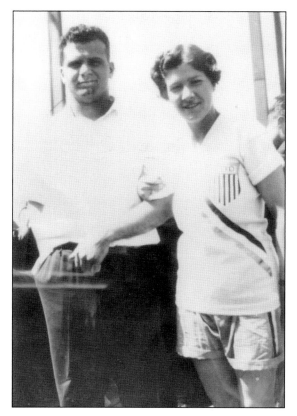

"BLOOMER GIRLS" SOFTBALL TEAM. The 1922 Santa Clara High School softball team, from left to right, included, Bobby Spegleman, second base; Elizabeth "Cookie" Kenyon, shortstop; Melvina Walcolz, catcher; ? Carroll, shortstop and second base; Sara Jenkins, third base; Johanna Lass, left field; Margaret Jenkins, pitcher; Arline McClellan, center field; Emma Roberts, right field; and Miss McNabb, coach. (Courtesy Margaret Jenkins, Bea Lichtenstein collection.)

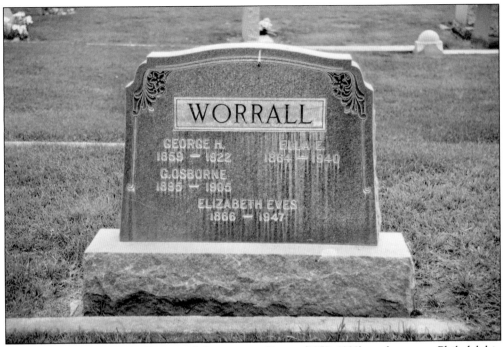

DR. GEORGE AND ELLA E. WORRALL MONUMENT. George (1859–1922) was born near Philadelphia and was educated in Pennsylvania. He came to California in 1891 as an experienced dentist, and married Ella Eaves (1864–1940) on July 14, 1891. They had four children, including Eoline (1893–1986), Osborne (1895–1905), and Lorraine (1904–?). The Worralls bought a house on the corner of Santa Clara and Main Streets that once belonged to Soledad Ortega Arguello and then her son Luis Antonio Arguello. (Courtesy Dave Monley Photography.)

DR. GEORGE WORRALL. In addition to his dental practice, George served on the school boards for both grammar and high schools in Santa Clara and was president of the board of education for six years. He was attending a basketball game at Santa Clara High when he suffered a heart attack and died. (Courtesy Santa Clara City Library from *History of Santa Clara County, California* by Eugene Sawyer, 1922.)

CAPT. RICHARD K. HAM MONUMENT.
Born in New Hampshire, Richard (1821–1887) was just 19 when he sailed on a whaling voyage to the South Pacific. He then worked in the Atlantic coast trade until 1848. He came to California for the gold rush, but discovered he could make more money by shipping lumber and other goods. In 1853, he opened a livery stable in Santa Clara. (Courtesy Dave Monley Photography.)

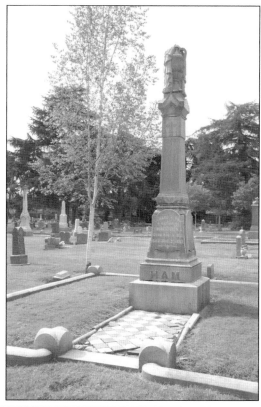

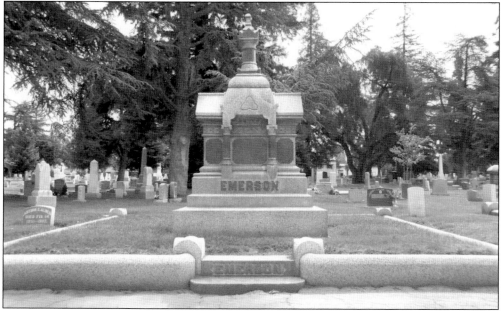

SILAS B. EMERSON MONUMENT. Silas (1819–1889) was the owner of a 900-acre tract of land two miles south of Mountain View. When he purchased his land in the mid-1800s, it was covered with large oak trees and he used it to grow grain. Upon his death in 1889, the land was bequeathed to his wife and two children. (Courtesy Dave Monley Photography.)

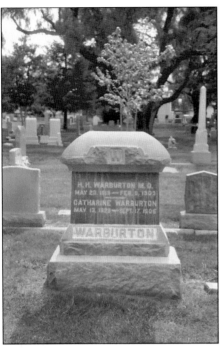

DR. HENRY H. AND CATHERINE WARBURTON MONUMENT. Dr. Henry H. Warburton (1819–1903) came from a long line of physicians in England. He came to America in 1844 and practiced in New York until signing on as surgeon on a whaling ship. Resigning his commission in 1847, Warburton eventually made his way to California and Santa Clara where he became the town's first physician in 1848. (Courtesy Dave Monley Photography.)

DR. HENRY H. AND CATHERINE WARBURTON. In 1855, Catherine Pennell (1829–1905), who had come to California by wagon train, married Dr. Henry H. Warburton in Santa Clara. The Warburtons raised a family of two daughters and three sons: Caroline (1860–1937), Ellen (1861–1949), John Pennington (1862–1950), Charles (1866–1947), and Henry Luke (1869–1947). The Warburton family was active in a wide variety of community affairs. (Courtesy Warburton family.)

Henry Luke Warburton. Henry Luke (1869–1947), the youngest son of Dr. Henry and Catherine Warburton, was born and raised in Santa Clara and attended local schools. He was a close friend of Robert A. Fatjo and both had an interest in athletics. They became noted tennis players in California and for a time were Santa Clara County doubles champions. (Courtesy Warburton family.)

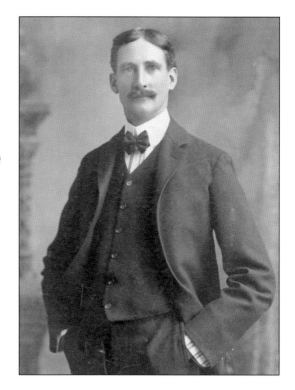

American Trust Bank. Luke was active in Santa Clara civic affairs. In 1910, he helped organize Mission Bank. Later he organized and became manager of the Santa Clara branch of Garden City Bank and Trust. It later merged with Mercantile Trust and then became American Trust Company. The bank building was later utilized as the city hall annex, after a new bank building on the corner of Lafayette and Benton Streets replaced the original building. Luke served as chairman of both advisory boards until he retired in 1935. (Courtesy Santa Clara Historic Archives.)

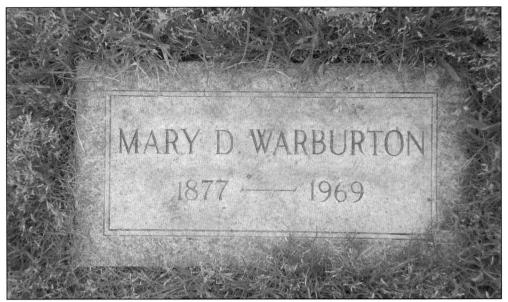

MARY DEN WARBURTON MARKER. Mary (1877–1969), daughter of Nicholas Den and Isabel Arguello, married Henry Luke Warburton on August 18, 1902. They had four children: Henry Luke Jr. (1903–1972), Rollo Pennington (1906–1914), Marie Ramona (1907–1994), and Austen Den (1917–1995). All four children were born and raised in Santa Clara and went to local schools. (Courtesy Warburton family.)

MARY DEN WARBURTON. Along with raising her family, Mary was active in many civic activities. She was a charter member of the Santa Clara Woman's Club which was organized in 1904. In 1913, Mary helped with the purchase and restoration of the old Pena Adobe which has served as the Woman's Club headquarters and meeting place from 1914 to the present. (Courtesy Warburton family.)

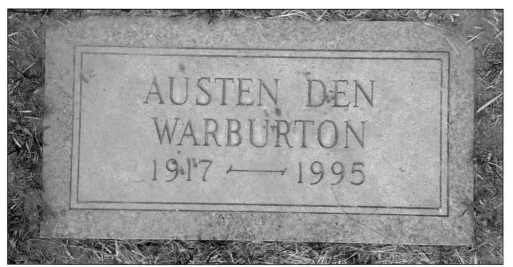

AUSTEN DEN WARBURTON MARKER. Austen "Bill" Warburton (1917–1995), the youngest son of Henry Luke and Mary Den Warburton, was a lifelong resident of Santa Clara. He attended Fremont and Santa Clara High Schools, graduated from San Jose State College, and then went to Santa Clara University where, in 1941, he received his law degree. For over 50 years, he was a practicing attorney and partner in the law firm of Campbell, Warburton, Britton, Fitzsimmonns, and Smith. (Courtesy Dave Monley Photography.)

AUSTEN DEN WARBURTON. Austen, a noted historian and author, was a member of many historical groups as well as a lecturer and tour leader on the history and archeology of California and the Southwest. Austen carried on his family's tradition of public service and involvement. Arts, cultural, civic, historical, Native American, youth, and senior groups all benefited during Austen's 78 years of service and caring. (Courtesy Warburton family.)

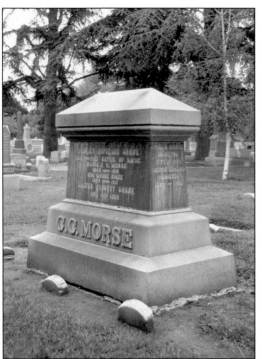

CHARLES COPELAND AND MARIA MORSE MONUMENT. Fourteen names of family and extended family are listed on the monument. Charles Morse (1842–1900) came to California in 1862 and became a house painting contractor. He continued this business for 12 years, and then became involved in seed growing. Morse spent 23 years in seed growing and earned the title of "Seed King of America." (Courtesy Dave Monley Photography.)

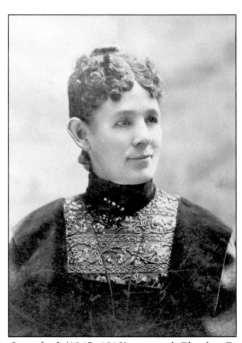

CHARLES COPELAND AND MARIA MORSE. Maria Langford (1845–1910) married Charles C. Morse. They had four children: Eva Augusta, born in 1869; Lester Langford, born in 1871; Stella May, born in 1873; and Winifred (Winnie), born in 1879. Maria was active in the Shakespeare Club and the Chautauqua movement and was a charter member of the Santa Clara Woman's Club when it organized in 1904. They both were founding members of the Santa Clara Advent Christian Church. (Courtesy Santa Clara Historic Archives.)

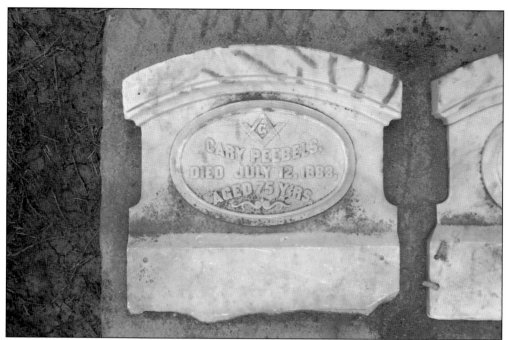

CARY PEEBELS MARKER. Cary (1808–1883) spent the first 41 years of his life in Kentucky and Missouri before he led an entrepreneurial venture to California in 1849. After arriving in California, he purchased his first 126 acres in Santa Clara Valley in 1851 for $7 per acre and became a farmer. He was one of the first to grow wheat for East Coast markets and to make strawberries a permanent crop. Note the Masonic emblem on the marker. (Courtesy Dave Monley Photography.)

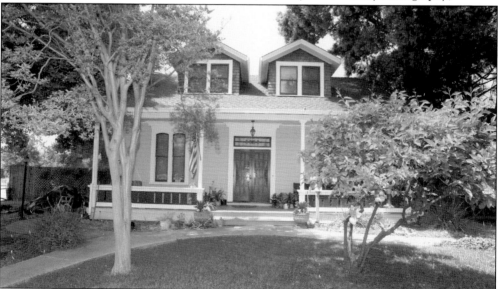

PEEBELS-HICHBORN HOUSE. The Hichborn house was built in 1868 by Cary Peebels for his wife, Susan. It has had several alterations and additions since that time and is a Santa Clara landmark property. Following Peebels death in 1883, the house was occupied from 1905 to 1963 by Franklin Hichborn, a crusading journalist who exposed graft and corruption in California government. (Courtesy Dave Monley Photography.)

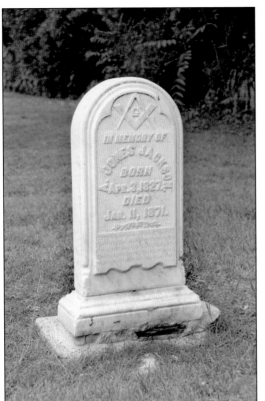

COL. ANDREW JONES JACKSON MONUMENT. Andrew (1832?–1890?) was born in New York City, but as a boy went to Florida to serve as a messenger for army officers during the Seminole War. At age 18, he enlisted in the Second Regiment of Ohio Volunteers and served during the Mexican War. Like so many others, he dug for gold in California in 1848, and then became a commissioned officer in the California Militia during the Civil War. Note the Masonic emblem on the monument. (Courtesy Dave Monley Photography.)

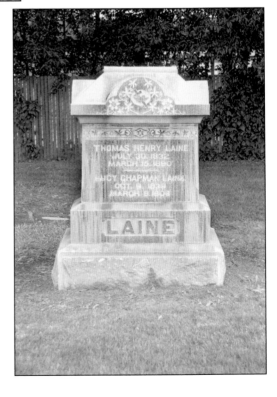

THOMAS HENRY AND LUCY LAINE MONUMENT. Thomas (1832–1860) was a member of the first graduating class of the College of the Pacific and gave the valedictory address. He was an attorney and was elected to the state senate twice, but was most proud of his selection to attend the Constitutional Convention in 1878. He and his wife, Lucy Chapman (1836–1906), had nine children. (Courtesy Dave Monley Photography.)

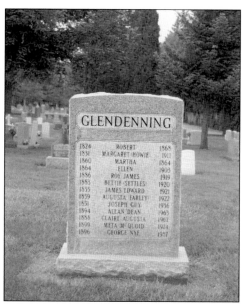

JAMES E. GLENDENNING. James (1855–1921) was born on the Glendenning Ranch on Homestead Road. His parents, Robert (1824–1868) and Margaret Howie (1831–1911), were immigrants from Scotland. Their children—Martha, Ellen, Roy James, and James Edward—are listed on the monument, as well as the children of James and Augusta—Joseph Guy, Allan Dean, Claire Augusta, George Nye, and his wife, Meta McQuoid. James was a rancher and farmer who served in the Santa Clara judicial system for 18 years. He served as justice of the peace from 1903 to 1921. Glendenning first heard cases in the 1891 city hall at Main and Benton Streets and then at the new city hall built in 1913. He was very active in the Masons, Oddfellows, and the Methodist Church. (Left photograph courtesy Judge Mark Thomas; right photograph courtesy Dave Monley Photography.)

FIRST CITY HALL AND JAIL. The first city hall was built in 1891 at the corner of Main and Benton Streets. The two-story brick structure housed city government functions and a court facility. Access to the second floor was by means of an outside stairway on the left side of the building. It also housed the jail on the first floor at the rear of the building. (Courtesy of Santa Clara Historic Archives.)

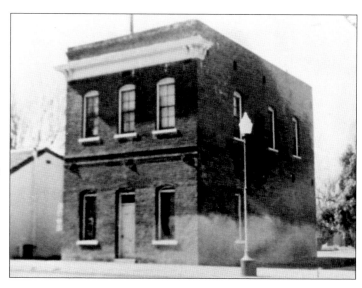

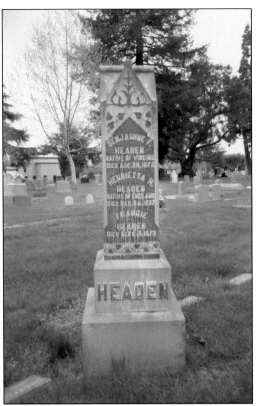

DR. BENJAMIN FRANKLIN AND HENRIETTA HEADEN MONUMENT. Benjamin (1813–1875) was born in Virginia village named Headenville, for his father. He studied medicine in Ohio and had a practice in Indiana until he came to the Santa Clara Valley in 1851. He bought 61 acres on the outskirts of the township of Santa Clara and built a house for his family. He first grew grain, then strawberries and other small fruits and, eventually, vegetable and flower seeds for the commercial market. (Courtesy Dave Monley Photography.)

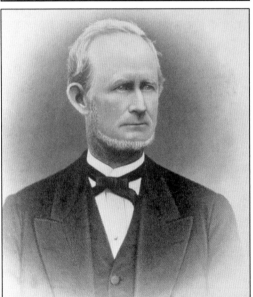

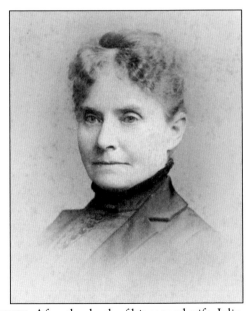

DR. BENJAMIN FRANKLIN AND HENRIETTA HEADEN. After the death of his second wife, Julia, Dr. Headen married a third time, in 1859, to a widow, Henrietta (Harvey) Johnson (1868–1897). Three children were born of this union: Henrietta H. (1861–1891), Thomasine (1864–1934), and Benjamin Franklin (Frankie) (1869–1873). After the death of her husband in 1875, Henrietta inherited the Headen property. (Courtesy Mrs. Irene Inman.)

LOUIS ALBERTSON MONUMENT. Born and raised on a farm in Denmark, Louis (1868–1928) came to America at age 18. He lived in Iowa before coming to California where he graduated from the College of the Pacific. Although he had a law degree, Louis preferred to be a dairy rancher and grow Himalayan blackberries. Louis was active in civic affairs, including a three-year stint as president of the Santa Clara Chamber of Commerce (Courtesy Dave Monley Photography.)

LOUIS ALBERTSON AND THOMASINE HEADEN. Thomasine was born in Santa Clara in 1864 to Dr. Benjamin Franklin and Henrietta Headen. In 1901, Thomasine married Louis Albertson. Thomasine had inherited the Headen property after the death of her mother, Henrietta, in 1897. Louis and Thomasine built a craftsman style house in 1913 to replace the original Headen house, built in 1860. (Thomasine photograph courtesy Mrs. Irene Inman; Louis photograph courtesy Santa Clara City Library from the official program and souvenir of the California Cherry Festival, Santa Clara, 1914.)

INMAN MONUMENT. Jesse Inman's name appears on the headstone, but the Inman Monument pays tribute to Dr. Benjamin Franklin Headen and to his family and descendents. A family genealogy diagram is on the back. Jesse was a realtor and land developer in the Stockton area, but he returned to Santa Clara on weekends. Lois and Jesse sold some of Headen land to the City of Santa Clara as the site for the present Civic Center. (Courtesy Dave Monley Photography.)

JESSE AND LOIS INMAN. Jesse Inman (1875–1963) married Lois Headen (1879–1972), granddaughter of Dr. B. F. Headen, on December 19, 1900, in Gilroy, California. Lois inherited the Headen property after the death of Thomasine (Headen) Albertson in 1934. The Inman's had two sons: Jesse Headen Inman (1901–1945) and Verne Inman (1905–1980). When Lois died in 1972, Verne inherited her property, which he and his wife, Irene, used as a "country home" until 1980, when Verne died. (Courtesy Mrs. Irene Inman.)

HEADEN-INMAN GENEALOGY. The diagram shows Dr. B. F. Headen and his three wives and the offspring of each marriage. First wife Sarah Ketcham Mitchell's son George married Mary Eva Reeve and their daughter Lois married Jesse J. Inman. Lois and Jesse's sons were Jesse Headen and Verne. The children of the second wife, Julia, were Sarah, Lina, and Martha. The children of the third wife, Henrietta, were Thomasine, Henrietta, and Frankie. (Courtesy Dave Monley Photography.)

HEADEN HOUSE. The home built by Dr. B. F. Headen was a splendid homestead, one of the most beautiful in the valley. Shown admiring the lovely landscaping around the house are, from left to right, Thomsine, Mrs. Headen, and Henrietta H. (Courtesy Mrs. Irene Inman.)

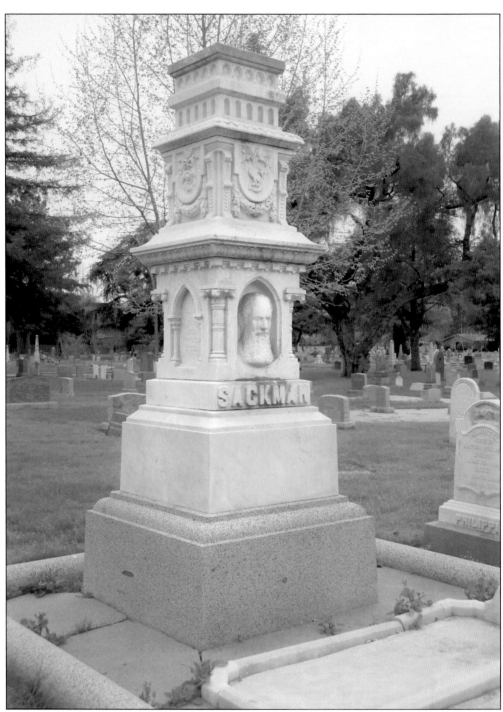

FREDERICK SACKMAN MONUMENT. A native of Brunswick, Germany, Frederick (1823–1878) was a machinist who died of "cerebral paralysis" at age 55. His monument features a death mask carved into the headstone. The death mask was made by pouring wax on the face of the deceased to make a mold that creates the face featured on this unusual monument. (Courtesy Dave Monley Photography.)

JOHN DIBBLE MONUMENT. John (1819–1896) started his life in Pittsburgh, and apprenticed as a tinsmith. After working at his trade in New York City for 11 years, he booked passage on a steamer for California in 1854 and settled in Santa Clara in 1857, opening a stove and tin workshop on Main Street near Franklin. The top of the monument features the three-ring emblem of the Oddfellows and an elaborate "swag" of flowers. (Courtesy Dave Monley Photography.)

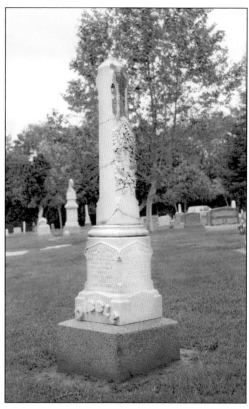

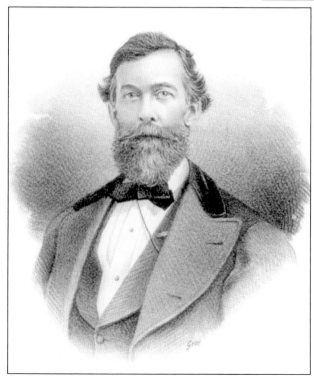

JOHN DIBBLE. John served on the town's board of trustees for seven years and on the board of education for five years. John married Lucy Parker (1841–1883) on June 21, 1860, in Santa Clara. Four children were born: George Ira (1860–1888); Frank (1862–1884); Julia, born in 1866; and Charles W. (1872–1933). The family lived in a house on Madison Street that still exists today. (Courtesy Santa Clara City Library from *History of Santa Clara County, California*, Alley, Bowen, 1881.)

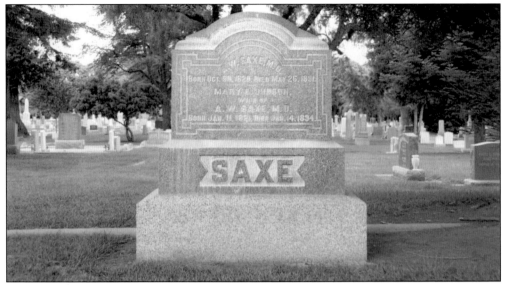

DR. ARTHUR WESLEY AND MARY SAXE MONUMENT. Dr. Saxe (1820–1891), the fourth son of Jacob and Rowena (Keith) Saxe, was born in New York. When he was 13, his family moved to Sheldon, Vermont, where he received his early education. He next attended Wesleyan University in Middletown, Connecticut, and then received his M.D. from Castleton Medical School in 1843. In 1852, he came to California and located in Santa Clara. (Courtesy Dave Monley Photography.)

DR. ARTHUR WESLEY AND MARY SAXE. In 1844, Dr. Saxe married his cousin, Mary Judson (1821–1894), in Sheldon, Vermont. Dr. Saxe made his trip to California over land in 1850, while Mary and their children Frederick (1846–1918) and Elizabeth (1848–1856) made their arduous voyage by sea, across the Isthmus of Panama in 1852. A second son, Francis Keith (1857–1892), was born in Santa Clara. Both Arthur and Mary were active members of the Santa Clara Methodist Episcopal Church. (Courtesy Mary Pascoe, Bea Lichtenstein collection.)

WISHING WELL. This unusual, ornately carved structure is the remains of a wishing well. It is thought to have had a metal framework structure on the top to hold the bucket. There is another complete structure like it in a Los Angeles cemetery. The Santa Clara wishing well is a mystery since it does not commemorate any known person. (Courtesy Dave Monley Photography.)

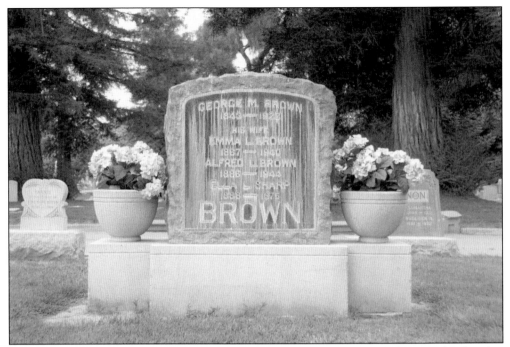

BROWN FAMILY MONUMENT. George Miller Brown was born in Gloucestershire, England, and as a child worked as a farm laborer on an English estate. He came to America in 1861 and arrived in California the following year. He partnered with Franklin Pancos to grow strawberries in Santa Clara. He later added a Bartlett pear orchard and other crops such as raspberries, blackberries, and alfalfa. (Courtesy Dave Monley Photography.)

GEORGE MILLER AND EMMA L. BROWN. George (1843–1922) married Emma Lobb (1867–1940) and they had five children: Alfred L., Ella L., Albert, Edith, and Walter G. The children grew up on the Brown ranch, went to local schools, and helped with the farming and the raising of Bartlett pears. (Courtesy Lois Brown.)

ALFRED, ALBERT, EDITH, AND ELLA BROWN. The children of George and Emma Brown include, from left to right, Alfred (1886–1944), who bought the Jamison family home and remodeled and modernized it for his Irish wife, Kilarney White; Albert, who married Viola Chews; Edith (sitting), who married Floyd Jamison; and Ella (1888–1975), who was a school teacher in the Jefferson District and married "Doc" Sharp. (Courtesy Lois Brown.)

JEFFERSON SCHOOL AND ELLA SHARP. The original Jefferson School, organized about 1861, was a one-room, wooden building located on Kifer Road on the northeast bank of San Tomas Creek, now San Tomas Expressway. Ella taught many years at Jefferson School. She was a member of the Brown family who grew Bartlett pears on the Brown ranch, where Great America is now located. (Courtesy Santa Clara Unified School District Archives.)

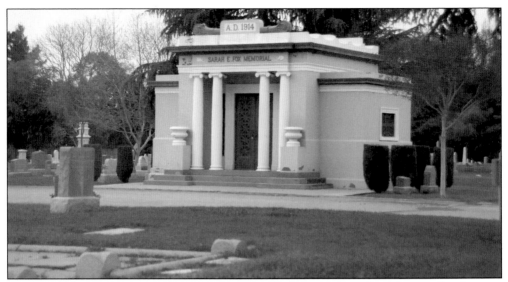

SARAH E. FOX MAUSOLEUM. This mausoleum was built as a memorial to Margaret Stephenson, wife of William Chainault Jones, and their daughter, Sarah Elizabeth, who was married to Charles W. Fox, M.D. It was presented as a gift to Santa Clara to be used as a community vault for the placement of cremains. The Sarah Fox Mausoleum contains 1,000 urns and is not open to the public. Sarah is buried in the Fox family grave area. (Courtesy Dave Monley Photography.)

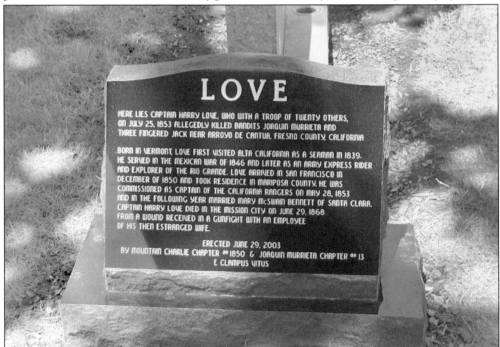

CAPT. HARRY LOVE MONUMENT. A member of the California Rangers, Harry (1809?–1868) is reputed to be the man who, in 1853, killed and beheaded legendary bandit Joaquin Murrieta for a $5,000 state reward. It is said he called himself "The Black Knight of Zayante." After his retirement from the Rangers, Harry moved to Ben Lomond to run a lumber mill. He is credited with putting in the first road to Felton. (Courtesy Mission City Memorial Park.)

JOHN MILLIKIN AND THE MILLIKIN SCHOOL. John (1807–1877) was born in Pennsylvania and spent his childhood in Ohio, Illinois, and Iowa. He and wife, Nancy, came to California in 1852 to settle on 80 acres near the present intersection of El Camino Real and Lawrence Expressway. The intersection contained the farm, a grocery store, and saloon and became known as Millikin's Corner. In 1855, a rural, one-room redwood cabin, with whitewashed walls, was named Millikin School in honor of John Millikin. (Courtesy Santa Clara Unified School District Archives.)

MILLIKIN SCHOOL. The original school was moved to the corner of Pomeroy Avenue and Homestead Road and later replaced with this new, larger building. Millikin School was the largest of the four rural schools that became a part of the Jefferson Union School District and, eventually, Santa Clara Unified School District. (Courtesy Santa Clara Unified School District Archives.)

Rev. Isaac Owen Monument. A native of Vermont, Owen (1809–1866) knew, at the age of 17, that he wanted to dedicate his life to the Methodist Episcopal Church. He was an illiterate blacksmith who became an avid reader and the church licensed him to "exhort" in 1830 and to preach in 1832. Owen was appointed as missionary to California in 1848 and came west in an ox-drawn wagon. He served as the first superintendent of the Methodist Church in California and helped organize the California Wesleyan College in Santa Clara which later became the College of the Pacific. His first wife, Elizabeth S., his second wife, Lucinda M., and his mother, Amy Low, are all buried in the Owen plot. (Courtesy Dave Monley Photography.)

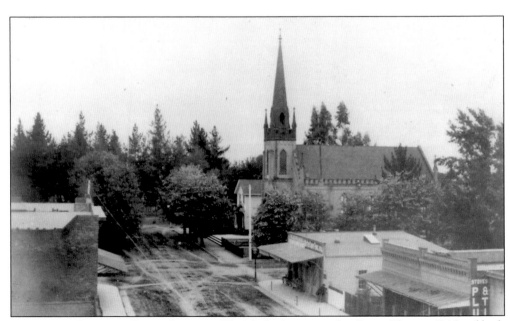

Methodist Episcopal Brick Church. The Methodists arrived in Santa Clara in 1846 and built their first church building of adobe brick in 1847. Construction of a second building, a beautiful Gothic church with buttressed red brick walls, pinnacles, and a steeple said to be 150 feet high, began in 1862 and was completed in 1867. (Courtesy of Santa Clara Historic Archives.)

SAMUEL IGNATIUS JAMISON MONUMENT. Samuel (1828–1901) was born in Maryland, but at the age of 21 headed to California. After one month of gold mining, Samuel switched to redwood lumbering and found it more lucrative. In 1850, he came to Santa Clara and bought a 185-acre ranch to grow strawberries, grain, and hay. He had three wives and sired 15 children, many of whom are buried in the Jamison plot. (Courtesy Dave Monley Photography.)

SAMUEL IGNATIUS JAMISON. While Jamison tended to his ranch, he served on the Santa Clara County Board of Supervisors and as a state assemblyman. He was director of the Bank of Santa Clara County and president of the Santa Clara Cheese Manufacturing Company. (Courtesy Santa Clara City Library from *History of Santa Clara County, California*, Alley, Bowen, 1881.)

JACOB EBERHARD. Jacob (1837–1915) was born in Germany and came to America in 1852. He first lived in Illinois where he worked as a harness maker but in 1858, came to California. He worked at his trade in Sacramento and then moved to Santa Clara in 1865 to buy part interest in the Santa Clara Tannery. He soon became its sole proprietor and changed the name to Eberhard Tannery. (Courtesy Dave Monley Photography.)

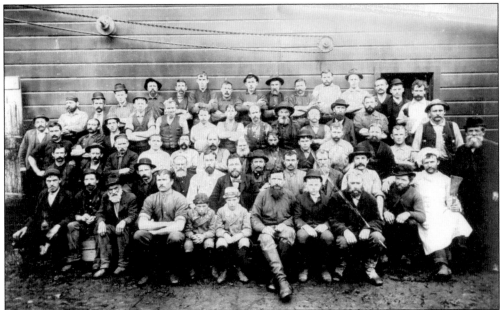

EBERHARD TANNERY EMPLOYEES. Eberhard Tannery provided employment for newly arrived immigrants from Germany and also provided employment, at times, for as many as one in five Santa Clarans. Eberhard Tannery grew to be the largest of it kind in California, eventually employing 70 men with an annual payroll of $50,000. Due to the reduced need for leather, the business closed in 1953—after 170 years of business. (Courtesy Santa Clara Historic Archives.)

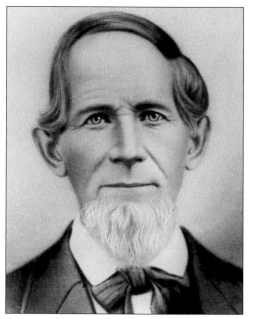
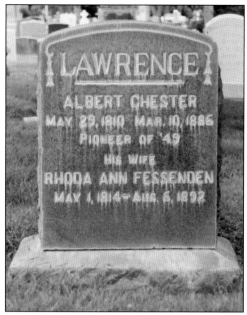

ALBERT CHESTER LAWRENCE. In 1834, Albert married Rhoda Fessenden (1814–1892). Their children included Albert Chester Jr., who married Rosa Harper of San Jose; William Howard (1837–1935) who married Susan E. Sleeper of Boston; Ellen E. who married Daniel Purdy of San Francisco; Elvira E.; and Adra A. who married, first, Henry Eaton of San Francisco and, then, P. G. Keith of Campbell Station. Albert and Rhoda celebrated their golden wedding anniversary in March 1886. Albert (1810–1886) was born in Boston and learned cabinetmaking as a youth. He caught gold fever in 1849 and sailed around Cape Horn to California in 1850. After two years in the mines, he settled in Santa Clara and purchased 80 acres for farming. He and his son, also named Albert, built a station and warehouse on the Southern Pacific Railroad line. It became known as Lawrence's Station, pictured below. (Sketch above left courtesy Santa Clara Unified School District Archives; photograph above right courtesy Dave Monley Photography; illustration below courtesy Clarence R. Tower.)

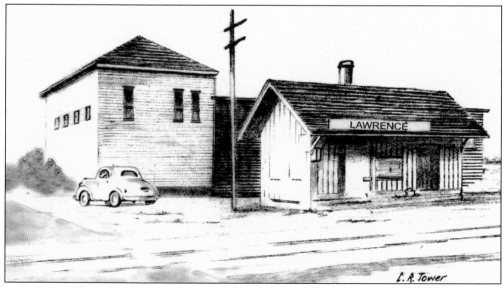

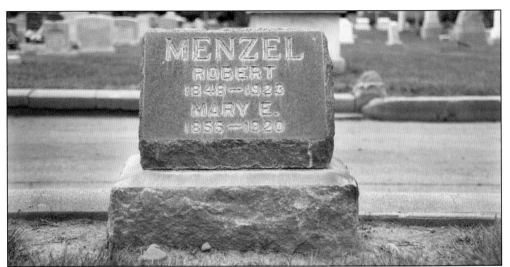

ROBERT AND MARY E. MENZEL MONUMENT. Robert (1848–1923) was born in Prussia and came to America with his parents when he was 12. They settled in Wisconsin and he apprenticed as a tinner. Robert came to California in 1869 aboard one of the first transcontinental trains on the Union Pacific line. He worked as a tinner in Sacramento. (Courtesy Dave Monley Photography.)

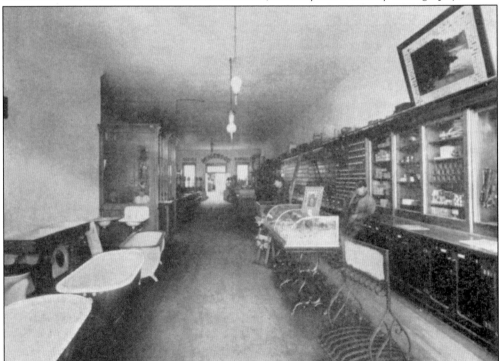

MENZEL HARDWARE INTERIOR. Robert Menzel came to Santa Clara in 1875 and became a hardware merchant. His business, Menzel Hardware, grew to include house furnishings and plumbing services. Menzel Hardware was a fixture on Franklin Street for many years. Robert served on the town's board of trustees, the board of education, had three terms as school superintendent, and three years as town treasurer. (Courtesy Santa Clara City Library from *Progressive Santa Clara*, 1904.)

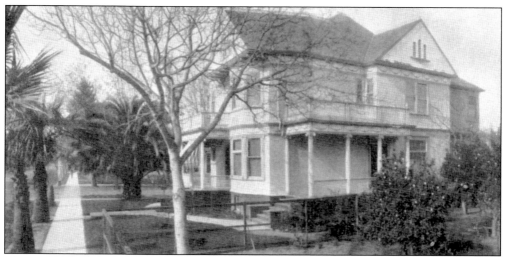

MENZEL RESIDENCE. In 1871, Robert married Mary Ellen Teaford (1855–1920), who was born in Virginia. They raised their children—Anna (b. 1872), Robert Henry (1875–1966), George (1878–1934), Frank (1879–1954), and Pearl (1887–1980)—in this house on Benton Street at the corner of Jackson. The house, an excellent example of Queen Anne–style architecture, is a Santa Clara landmark property and remains today little changed from this *c.* 1904 photograph. (Courtesy Santa Clara City Library from *Progressive Santa Clara,* 1904.)

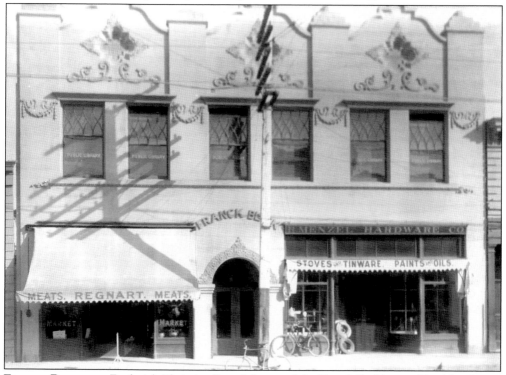

FRANCK BUILDING. Frederick Christian Franck I erected the Franck Building on Franklin Street, which housed Regnart Meats and Menzel Hardware on the street level. The second floor housed the Santa Clara Public Library until 1913, when the library moved into the new city hall on the corner of Franklin and Washington Streets. (Courtesy Santa Clara Historic Archives.)

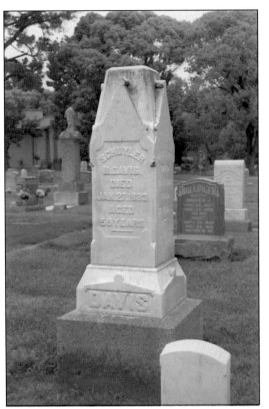

SCHUYLER B. AND LUCINDA DAVIS MONUMENT. Schuyler (1824–1883) was raised as a farmer in North Carolina. After attending Eastabrook College, he managed a toll road for his father and then moved to Missouri to engage in cattle dealing. Schuyler purchased a farm upon arriving in 1852 and in August 1856, he bought another 140-acre farm. In 1868, he established large grain warehouses at Lawrence's Station, thus affording storage and ready shipment for the product grown in the area. (Courtesy Dave Monley Photography.)

SCHUYLER B. DAVIS. Schuyler married Lucinda F. Beaty (1836–1906), a native of Kentucky on September 2, 1846, and they resided in Missouri. Three children were born to this union: Sarah E., Emma H., and Charles C. In 1852, the family accompanied Davis when he made a second overland trip to California, arriving in Placerville on July 17. After settling his family in Santa Clara, he purchased a farm on Alviso Road about a mile southwest of Santa Clara. (Courtesy Santa Clara City Library from *History of Coast Counties, California* by J. M. Guinn, 1904.)

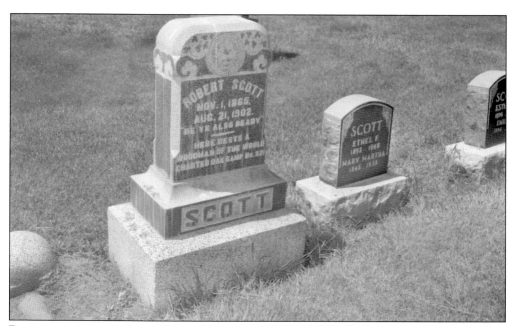

ROBERT AND MARY MARTHA SCOTT MONUMENT. Robert (1865–1902) and Mary Martha Bunting (1865–1938) were both from County Armagh, Northern Ireland. Robert came to California and San Francisco in 1890. In 1884, Mary Martha left for New Zealand, sailing from Plymouth, England. She was 18 years old and registered as a dressmaker. Her family had intended to move to New Zealand, but due to the ill health of Mary's mother, Mary had gone on ahead to wait for them. (Courtesy Dave Monley Photography.)

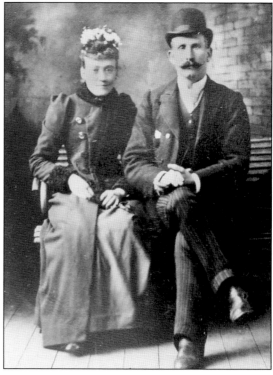

SCOTT WEDDING PHOTOGRAPH. Some time after 1888, Mary went to San Francisco where she met Robert Scott at the Presbyterian Church they both attended. They married on October 5, 1891. Robert worked as a machinist at the Union Steel Works, forerunner of Bethlehem Steel. Two daughters, Ethel Frances (1892–1968) and Emily Bunting (1891–1977), were born in San Francisco. (Courtesy Esther Scott, Bea Lichtenstein collection.)

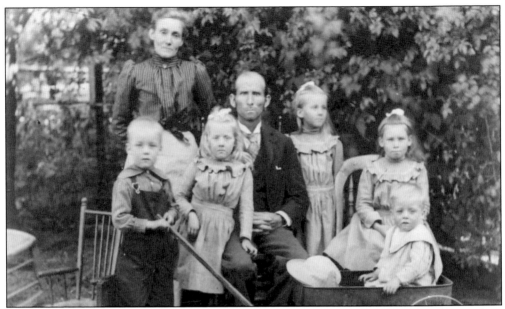

SCOTT FAMILY. The Scott family moved to Cupertino, then known as Westside, where Robert became foreman of the Alex Montgomery Ranch on Stevens Creek Road. Esther Anna, Oliver Dobbin, and Francis Taylor were born in Cupertino. The family pictured here are Oliver (front) and Francis (in the wagon), (back from left to right) Mary Martha, Emily, Robert, Ethel, and Esther. Robert suffered ill health and died of tuberculosis (then called consumption) on August 21, 1902. (Courtesy Esther Scott, Bea Lichtenstein collection.)

SCOTT FAMILY HOUSE. Robert, as a member of the Woodmen of the World, carried a life insurance policy of $3,000. Mary Martha used this to purchase property with a five-room house in Santa Clara. The house at 1587 Harrison Street served the family from 1902 to 1920. From 1920 to 1958, the family lived at 1597 Harrison. (Courtesy Esther Scott, Bea Lichtenstein collection.)

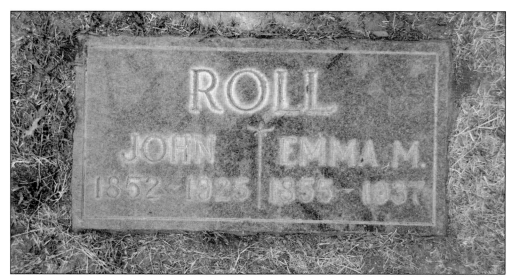

JOHN AND EMMA M. ROLL MARKER. John (1852–1925) started his life in Wisconsin, but went to Arizona in 1881 to build sawmills on Turkey Creek for the Yavapai Mine Company. He migrated to California in 1884 and was employed at the Pacific Manufacturing Company, a Santa Clara lumber mill. He was active in civic affairs and served on the town board of trustees and the Santa Clara Board of Supervisors. He married Emma Runge (1855–1937) and they had four children. (Courtesy Dave Monley Photography.)

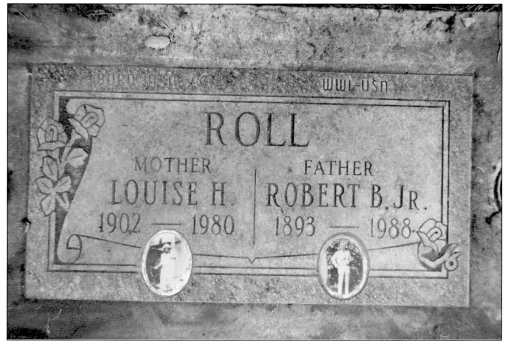

ROBERT B. (1893–1988) AND LOUISE (1902–1980) ROLL MARKER. Robert Blum Roll, a nephew of John Roll, was president of the Enterprise Laundry Company in Santa Clara. He was active in many civic organizations including the school board, the Central Coast Counties Improvement Association, and the Santa Clara Laundrymen's Association. He helped to organize the Santa Clara Commercial League and served as the first president. (Courtesy Dave Monley Photography.)

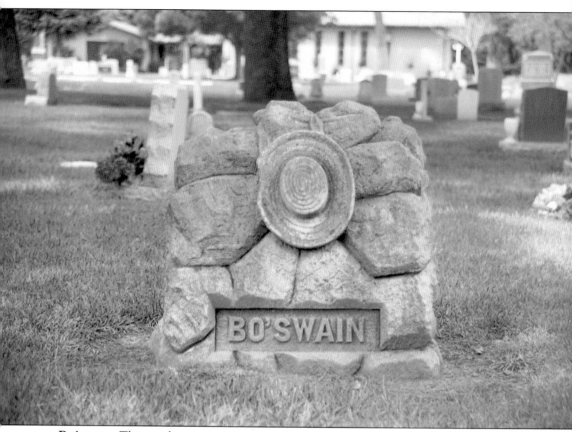

BO'SWAIN. This sandstone monument marks the grave of an unidentified boatswain (a petty officer on a merchant ship having charge of hull work and related duties). No one knows who is buried here. The headstone features a flat crowned hat that could have been worn by a child or a sailor. One legend says it is a memorial to a child drowned at Santa Cruz and whose hat washed up on shore. Another more likely legend believes it refers to a Portuguese sailor who died and was buried at the old Mission Santa Clara Church in 1823. (Courtesy Dave Monley Photography.)

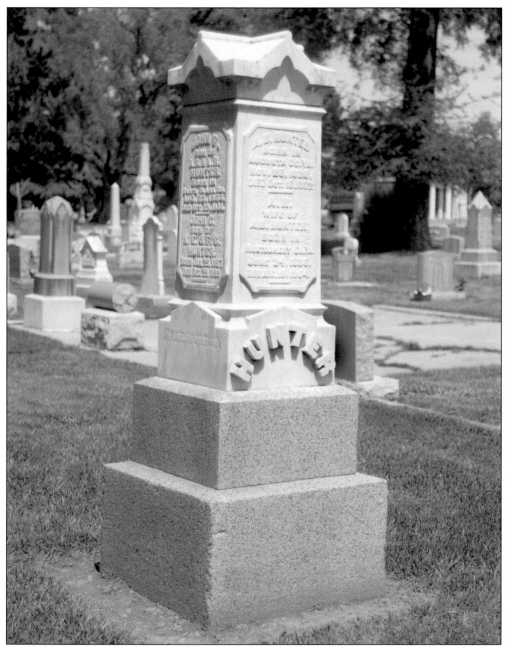

AUGUSTUS BROOKS AND ANN RUTLEDGE HUNTER MONUMENT. Augustus (1826–1902), who liked to be called "Gus," was born in Virginia and grew up in Illinois and Missouri. He came to California's gold country in 1849 but planned to move on to the Sandwich Islands (Hawaii) because of poor health. A trip to the mild climate of Santa Clara in 1852 changed his mind and he settled here, purchasing a 160-acre farm. He was treasurer of the Santa Clara Cheese Factory and served two terms in the state legislature. He and his wife, Ann (1835–1904)—a descendant of Edward Rutledge, a signer of the Declaration of Independence—had five children: John Finley (1856–1881); Minnie Jane (1858–1938); Frank, born in 1860; Carrie, born in 1863; and Archibald Ernst, born c. 1875. (Courtesy Dave Monley Photography.)

EDWIN H. AND HANNAH DAVIES PLOT. Edwin (1819–1882) was born in Maine, the son of a well-to-do farmer. His first job off the farm was as a bell-hanger in Boston. He returned to Maine to work with his brother in manufacturing fancy sleighs and buggies. He worked as a mechanic in various places before coming to California in 1854. He settled in Santa Clara in 1855 and opened the Santa Clara Machine Shop. (Courtesy Dave Monley Photography.)

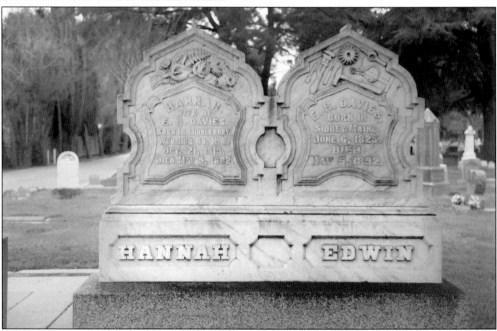

EDWIN H. AND HANNAH MONUMENT. Several years later, Davies opened the three-story Davies Machine Shop on the corner of Jackson and Liberty Streets. Edwin wanted people to know that he was an inventor and machine shop owner, so he had a hammer, wrench, chisel, t-square, and other tools carved into his ornate headstone. His wife, Hannah (1825–1892), has an ornately carved headstone with roses and other flowers which stand out in lifelike relief. (Courtesy Dave Monley Photography.)

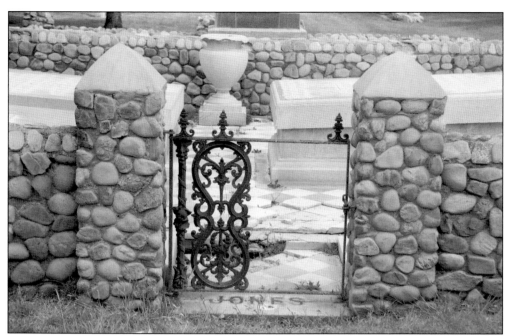

GATE TO FOX FAMILY PLOT. Through the elaborate gates is the final resting of Sarah Fox, namesake of the Sarah Fox Mausoleum. The monument is in memory of Sarah Fox Jones and her husband of over 50 years, Dr. Charles W. Fox, and presumably their son, James Gillon (1844–1922). (Courtesy Dave Monley Photography.)

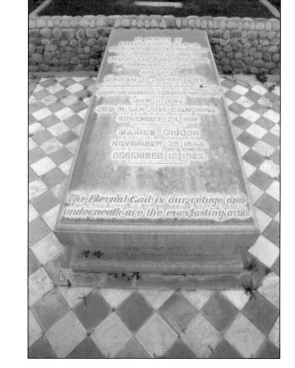

CHARLES W. AND SARAH JONES FOX. Charles W. Fox, M.D. was born in Lancaster, Kentucky, on February 23, 1826, and died in San Jose, February 17, 1912. Sarah was born in Monroe County, Missouri, July 11, 1842, and died in San Jose on November 24, 1912. This monument suggests a long and happy marriage between Charles and Sarah. (Courtesy Dave Monley Photography.)

FREDERICK CHRISTIAN AND CAROLINE FRANCK MONUMENT. Frederick (1828–1902) was born in Bavaria, Germany, and left school at age 15 to learn how to make harnesses and saddles. After coming to America, he made saddles for the American government to use in the Mexican War, then worked his trade in cities across the country. He arrived in Santa Clara in 1855 and became a partner in Henry Messing's harness and saddle business. (Courtesy Dave Monley Photography.)

FREDERICK C. AND CAROLINE FRANCK WEDDING PICTURE. Caroline Durmeyer (1834–1900), also a native of Germany, married Frederick Franck in Santa Clara on September 23, 1857. The Francks were the parents of eight children, but only two survived to maturity: Caroline (1877–1949) and Frederick (Fred) Christian Franck II (1873–1954), who married Maude Shuld (1879–1960). (Courtesy Santa Clara Historic Archives.)

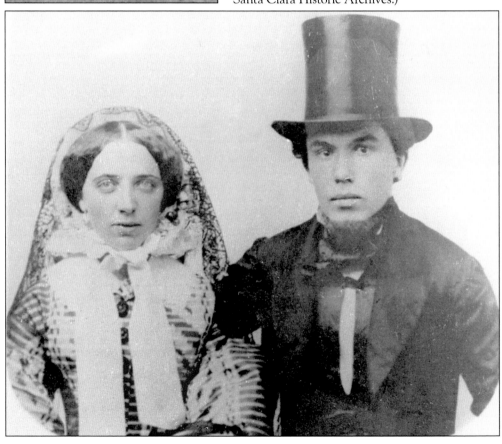

FRANCK MANSION. The Francks built a Queen Anne–style Victorian mansion, designed by Theodore Lenzen, at the corner of Washington and Benton Streets, where the Wells Fargo Bank is presently located. After the death of Caroline and Frederick Franck, their daughter Caroline inherited the property and lived there until her death in 1949. (Courtesy Santa Clara Historic Archives.)

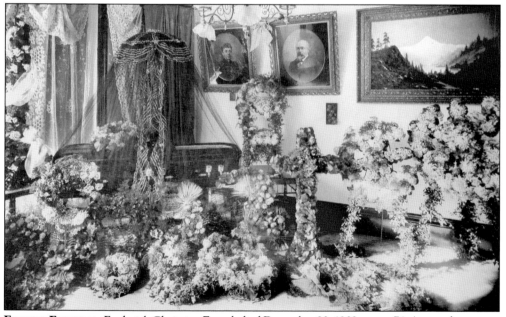

FRANCK FUNERAL. Frederick Christian Franck died December 20, 1902, at age 74. As was the custom in those days, the body and casket were displayed in the parlor and funeral services were conducted from the family home. The services were held under the auspices of Santa Clara Odd Fellows Lodge No. 52 and True Fellowship Lodge 238, whose members accompanied the funeral procession to the city cemetery where Frederick was laid to rest. (Courtesy Santa Clara Historic Archives.)

MAJ. JOHN A. COOK. John (1796–1877) was born on the Isle of Wight in England and boasted to being a descendent of William the Conqueror. He came to America in 1819 and lived in Ohio and Indiana where he was commissioned a major of the battalion of Militia Cavalry, served as state librarian, and gained some fame as a temperance lecturer. (Courtesy Mary Pascoe, Bea Lichtenstein collection.)

JOHN COOK HOUSE. John came to California in 1849 and took charge of the custom house in San Diego. After attending the California Legislature when it convened in San Jose, he moved to Northern California and settled in Santa Clara in 1851. He married Jane Fulkerson, born in Nova Scotia in 1809, on March 30, 1851. The Cooks built a home in the summer of 1853 on Deep Springs Lake (later called Cook's Pond) just off the Alameda. (Courtesy Mary Pascoe, Bea Lichtenstein collection.)

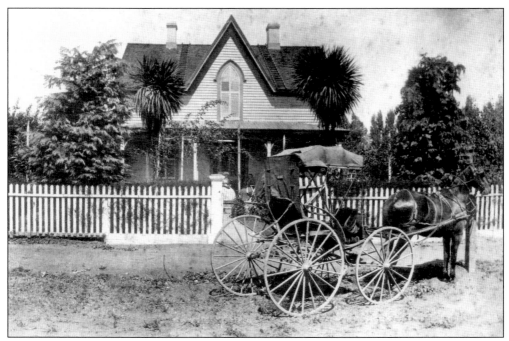

NATHANIEL COOK HOUSE. Nathaniel (1818–1898), born on the Isle of Wight, came to America with his parents, John and Theodora Cook, in 1819 and lived in Indiana. Nathaniel and his wife, Eliza, came to California in 1857. Nathaniel worked at and became one of the owners of the Santa Clara Flour Mill. He also served as a township justice of the peace and foreman of the county grand jury. (Courtesy Mary Pascoe, Bea Lichtenstein collection.)

NATHANIEL AND ELIZA COOK. Nathaniel married Eliza Jane Hubbell (1827–1911) in Springfield, Ohio, on July 2, 1846. After settling in Santa Clara, the Cooks built a lovely Gothic-style home at Lewis and Lafayette Streets. Mary Jane (Minnie), a daughter, was born in Santa Clara on February 23, 1960. She attended local schools and married a fellow Santa Claran, Dr. Francis Keith Saxe, on November 23, 1883. (Courtesy Mary Pascoe, Bea Lichtenstein collection.)

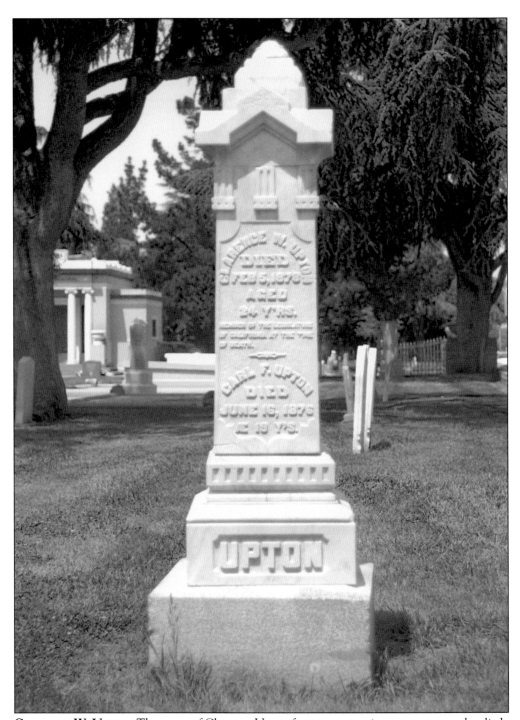

CLARENCE W. UPTON. The grave of Clarence Upton features a prominent monument, but little is actually known about his life. He is listed in documents as the proprietor of the *Santa Clara Echo* newspaper and as Santa Clara's city clerk in 1874. He was elected to the California State Assembly in 1877 and died in office in 1878. The monument states he died February 5, 1873, at age 24. (Courtesy Dave Monley Photography.)

Part II
SANTA CLARA MISSION CEMETERY

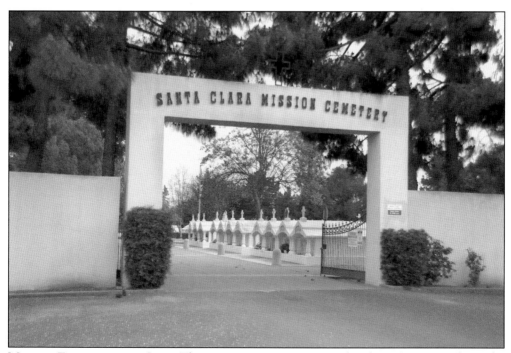

MODERN ENTRANCE AND GATE. The present entrance was erected in the 1960s to provide a wider road into the cemetery that would better accommodate automobile traffic—since the original road was intended for horse and buggy use. (Courtesy Dave Monley Photography.)

INTRODUCTION

The rich history of Santa Clara and Santa Clara Valley dates back to the arrival of Spanish explorers in what became known as the Santa Clara Valley. Capt. Gaspar de Portolá and his party became the first Europeans to arrive in the area in November 1769.

The Spanish established the eighth of 22 missions on January 12, 1777, as Mission Santa Clara de Asis. The missions were established by the Franciscan Order.

The first Catholic cemetery in the Santa Clara Valley was founded by the same Franciscan Fathers who founded Mission Santa Clara de Asis in 1777. Within the space of 50 years, Mission Santa Clara changed its location four times. With each site there was a new cemetery. The cemetery at the fourth site is located on today's campus of the University of Santa Clara.

With the founding of Santa Clara College in 1851, there was need for a new cemetery site to serve the Catholic community in Santa Clara and Santa Clara Valley. The new location chosen was a short distance from the old mission church and is still the site of Santa Clara Mission Cemetery.

Many prominent pioneers who played a role in the history of this area are buried here. In keeping with Jesuit tradition, the many fathers and sisters who have served the Santa Clara Valley are buried with their congregations. As a Catholic cemetery, Santa Clara Mission Cemetery serves the needs of the religious community at Santa Clara University and the sisters of Notre Dame College. The sisters founded Notre Dame College in downtown San Jose in 1851 and in January 1864 extended their work to open a private academy for girls in Santa Clara. They also taught boys in the old red brick building known as St. Joseph's School.

Walking through the cemetery is like walking through a portion of the valley's past. Inside the cemetery one finds a century-old display of cemetery art from delicate marble angels to lofty spires and crosses of all shapes and sizes. Many a pioneer monument has a mossy beauty all its own. A person can learn about the area's history and the people associated with the history as well as receive an art appreciation lesson at the same time.

A WALK THROUGH HISTORY

In 1851, Santa Clara College was founded by Jesuit Frs. John Nobili and Michael Accolti. They realized that the old cemetery by the Mission Church was full and accordingly that same year they began a search for a new cemetery site.

The site they selected was a few minutes walk from the Mission Church and was located near the small adobe home of Don Fernando Berryessa. That site is still today's location of Santa Clara Mission Cemetery.

From the first burials until today, the cemetery has constantly grown. Remembering its first tradition, the cemetery still serves the valley in the tradition of the Franciscan Fathers. Buried at Santa Clara Mission Cemetery are many early pioneers including Spaniards, Mexicans, Americans, and others of rich and varied ethnic backgrounds. Here all sleep in quiet dignity that bespeaks the way of a Santa Clara Valley which has passed into history.

Since those early days, the cemetery has been enlarged and improved. In 1901, an underground mausoleum was built, a chapel was added above the mausoleum in 1902, and a 1906 addition gave the chapel its present form. Beneath the chapel rest many pioneers in what may be the valley's first underground mausoleum. The chapel was named in honor of Aloysuis Varsi, S.J., the sixth president of Santa Clara College.

Features include the massive gate erected to the memory of Judge Myles P. O'Connor, an early philanthropist. At the same time, Mrs. Amanda O'Connor also donated the road that ran beneath the gate. The paving was purposely roughened to keep horses from slipping on a rainy day. Much of the gate was demolished by the Loma Prieta earthquake in 1989. Other features added over the years include: the Mausoleum in the center of the cemetery, built in the early 1930s; the Garden Crypts built in 1961; Mission Garden Crypts built in 1977; St. Clare Chapel Mausoleum built in 1987; and St. Joseph Mausoleum built in 1997.

Today repairs and time have erased the marks left by the 1906 and 1989 earthquakes at the Mission Cemetery. Constant restoration preserves much of the cemetery as it has been for well over a century and a half.

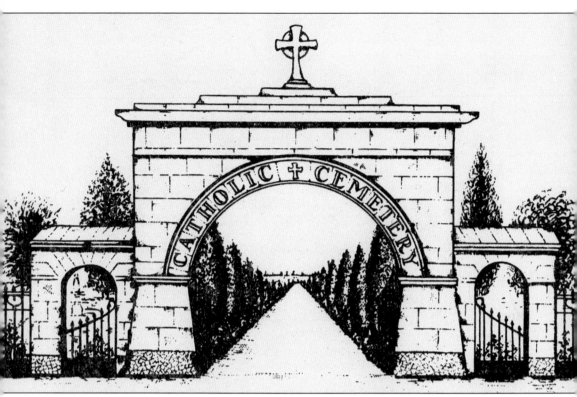

ORIGINAL GATE DRAWING. In 1909, the original massive gate was erected to the memory of Judge Myles P. O'Connor, an early philanthropist of note, by his widow. At the same time, Mrs. O'Connor also donated the road that ran beneath the gate. The paving was purposely roughened to keep horses from slipping on a rainy day. (Illustration by Ralph Rambo.)

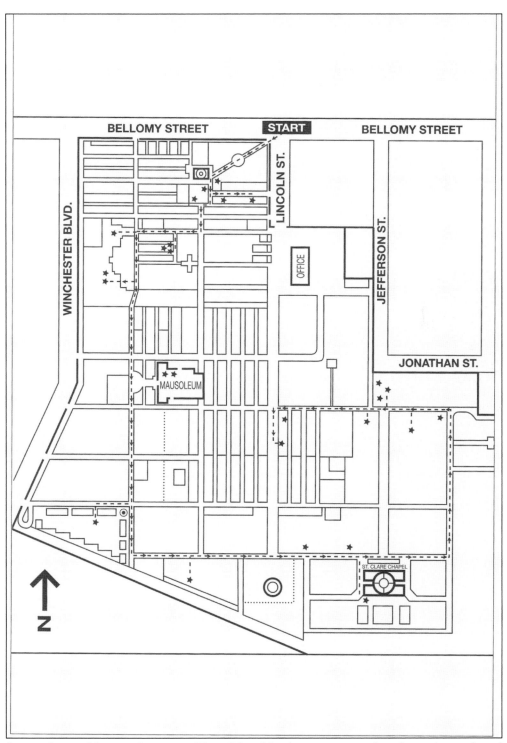

SANTA CLARA MISSION CEMETERY TOUR MAP. Use this map as a guide to learn about selected people buried in Santa Clara Mission Cemetery. Start at the old Gate entrance and follow the arrows for your tour. (Courtesy Guild West.)

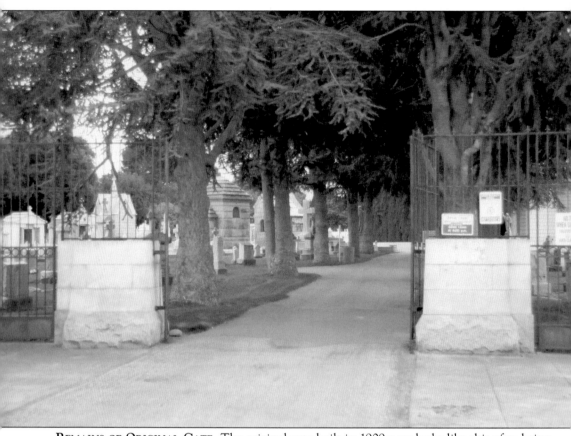

REMAINS OF ORIGINAL GATE. The original gate built in 1909 now looks like this after being demolished by the Loma Prieta earthquake in 1989. It is still used as an entrance into Santa Clara Mission Cemetery and its leads to the commemorative statue for Myles O'Connor (1823–1909) and Varsi Chapel. (Courtesy Dave Monley Photography.)

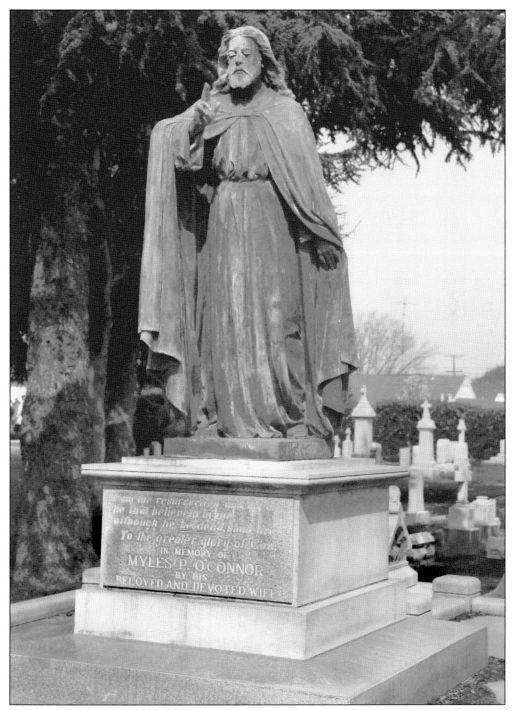

O'Connor Memorial Statue. Born in Ireland and educated in the United States and England, Myles amassed a huge fortune and later served as a noted lawyer and judge. A philanthropist of note, O'Connor and his wife, Amanda, donated many hours and dollars to Santa Clara County, their lasting monument being the O'Connor Sanitarium, today's O'Connor Hospital. (Courtesy Dave Monley Photography.)

VARSI CHAPEL EXTERIOR. In 1901, an underground mausoleum was built at the cemetery. A chapel was added above the mausoleum in 1902, and a 1906 addition gave the chapel its present form. The chapel was named in honor of Aloysuis Varsi, S.J. (1830–1900), the sixth president of Santa Clara College. Beneath the chapel rest many pioneers in what was probably the valley's first underground mausoleum. This view of the chapel is taken from the old entrance road side. (Courtesy Dave Monley Photography.)

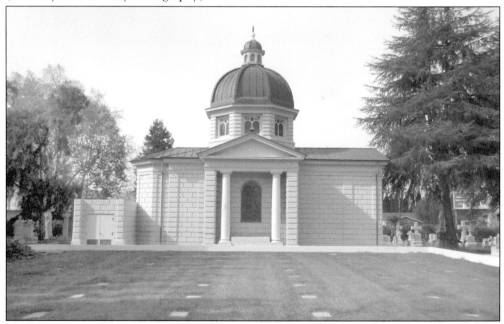

VARSI CHAPEL EXTERIOR. This view of the Varsi Chapel is from the back of the structure and features the dome with its cupola and one of the beautiful stained glass windows. In front of the chapel is the plot where the Jesuit Priests are buried. (Courtesy Dave Monley Photography.)

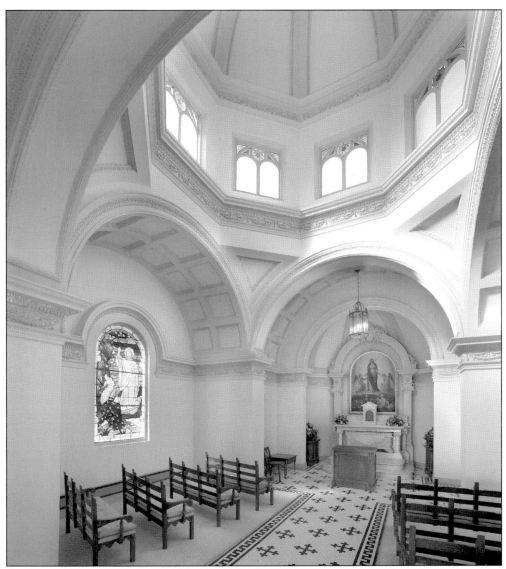

VARSI CHAPEL INTERIOR. Inside the Varsi Chapel is a center aisle of black and white tile, hand-fashioned when the chapel was built. The same tile floor surrounds the beautifully carved marble altar. The cathedral-style center dome with its stained glass windows was restored and is highlighted with gold leaf. This facility is open to the public only for special tours, although it can be used for services of those being buried at Santa Clara Mission Cemetery. (Courtesy Dave Monley Photography.)

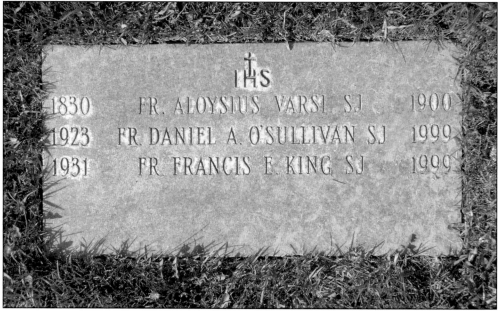

ALOYSIUS VARSI, S.J. MARKER. Fr. Aloysius Varsi, an Italian Jesuit, is buried in the priests plot in front on his namesake Varsi Chapel. Varsi joined the faculty at Santa Clara College in 1864 and served as its sixth president from 1868 to 1876. The markers are arranged in chronological order. (Courtesy Dave Monley Photography.)

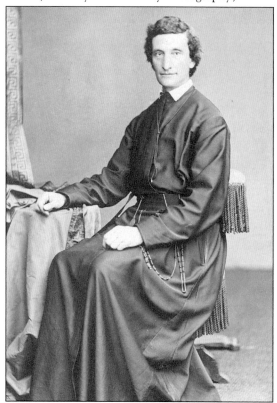

ALOYSIUS VARSI, S.J. During his presidency, Fr. Aloysius Varsi began construction of a new structure that served as both dormitory and theater, despite the large debt of the college. It was called "The Ship" and had a large 130-bed dormitory on the first floor. The second floor theater seated 3,000 and served for debating, dramatic productions, and musical performances. (Courtesy Santa Clara University Archives.)

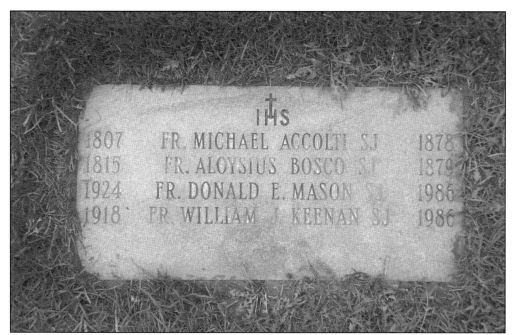

MICHAEL ACCOLTI, S.J. MARKER. Father Accolti (1807–1878), an Italian Jesuit in the Pacific Northwest in the 1840s, was the founder of the California Jesuits in 1849. In 1851, he was also cofounder of Santa Clara College along with John Nobili, S.J. (Courtesy Dave Monley Photography.)

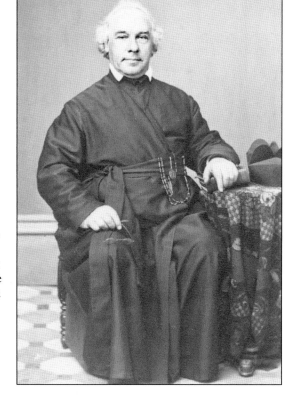

MICHAEL ACCOLTI, S.J. While John Nobili served as the first president of the fledgling Santa Clara College, Accolti used his talents and persuasion to recruit an experienced faculty. He persuaded the Jesuits of Turin, Italy, to adopt California as a permanent mission. This opened up a source of university-trained teachers for Santa Clara College and, by 1855, the college had a faculty of 18 priests and laymen. (Courtesy Santa Clara University Archives.)

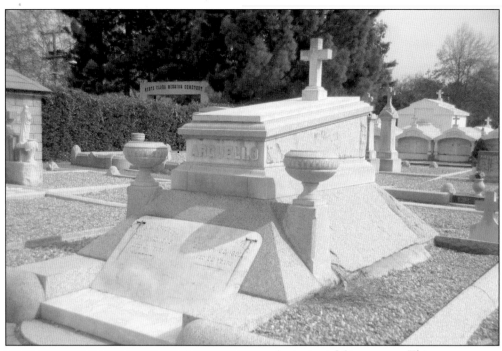

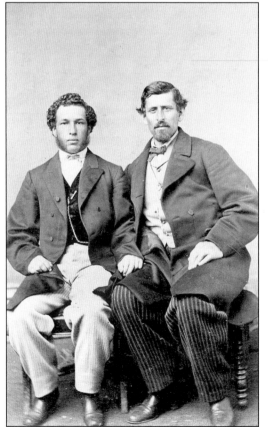

ARGUELLO MONUMENT. This monument honors one segment of the Arguello family who were prominent in early California history. Jose Dario Arguello came to Monterey with the Rivera y Moncada Expedition in 1774, was commandant of the San Francisco Presidio, and acting governor of Alta California. His son Luis Antonio was the first native born governor of Alta California under Mexican rule, 1822–1825. Luis Antonio's wife was Soledad Ortega. (Courtesy Dave Monley Photography.)

LUIS ANTONIO ARGUELLO. Luis Antonio Arguello (1830–1898), the youngest child of Luis Antonio and Soledad (Ortega) Arguello, was born four months after the death of his father in 1830. Luis Antonio came to Santa Clara with his mother and brother Jose Ramon in 1857. Luis Antonio is shown on the right with his cousin Ignacio Malarin on the left. (Courtesy Warburton family.)

LUIS M. AND ELISA R. FATJO MONUMENT.
The Fatjo families of Santa Clara have
a long and illustrious history, not only
in this community, but also in Spain,
particularly in Barcelona as early as the
13th century. The first of the Fatjo family to
settle in Santa Clara was Antonio, born in
Barcelona, Spain, in 1828. Antonio had five
children: Antonio V. (1849–1917), Amelia
(1853–1922), John F. (1855–1930), Clorinda
(b. 1857), and Luis M. (1860–1924).
(Courtesy Dave Monley Photography.)

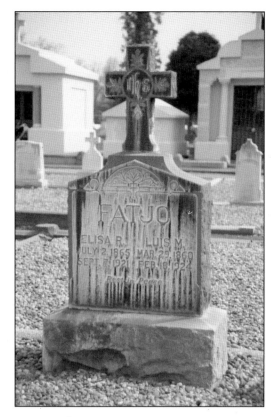

LUIS M. FATJO. Luis M., the youngest son of Antonio
and Marianna Fatjo, was born during a trip to Spain,
in 1860. Luis, who grew up in Santa Clara as part of
the locally prominent Fatjo family, married Elisa A.
Raventos (1865–1921), the sister of his brother John's
wife, Teresa Raventos. The children of Luis and Elisa
included twins Rosita and Conina, who died young;
Emily, Anita, and Luis George. (Courtesy Santa Clara
City Library from California Cherry Festival, Santa
Clara, Official Program and Souvenir, 1914.)

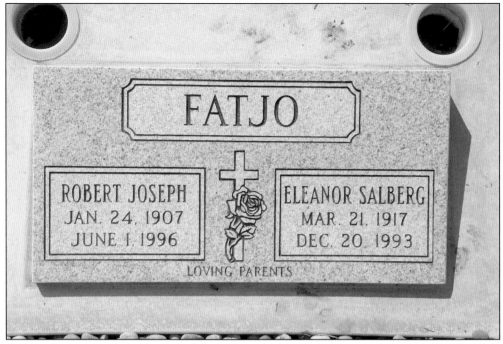

ROBERT J. AND ELEANOR SALBERG FATJO MONUMENT. Robert J. (Bob) Fatjo (1907–1996), the son of Robert A. and Teresa Fatjo, was born in Santa Clara on January 24, 1907. He attended grammar school at St. Joseph's School which was located where St. Clare's Church now stands. Bob attended Santa Clara University High (renamed Bellarmine College Preparatory in 1928). Bob met Eleanor Salberg (1917–1998), a member of another prominent local family, and the couple married in 1956. (Courtesy Dave Monley Photography.)

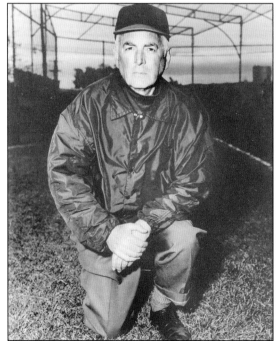

ROBERT J. FATJO. Bob began his coaching career in 1941 at Santa Clara University as coach of the freshman baseball team. In 1943, he was named baseball coach at Bellarmine College Preparatory and continued to coach there for 27 years. In 1946, he also assumed the duties of director of athletics and physical education instructor. Bob retired from Bellarmine in 1973, and was a member of the City of Santa Clara Parks and Recreation Commission for 12 years. (Courtesy California History Center, De Anza College, Cupertino.)

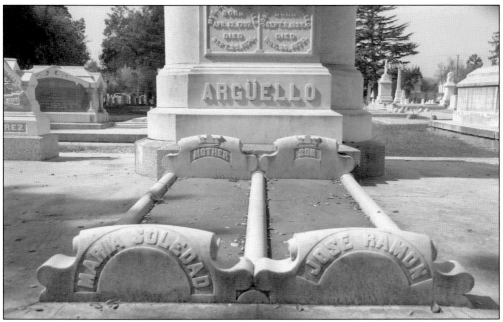

SOLEDAD ORTEGA AND JOSE RAMON ARGUELLO MONUMENT. This monument is a tribute to an early California family, the Arguellos. Maria Soledad Ortega, granddaughter of Sgt. Jose Francisco de Ortega (1782–1798), the discoverer of San Francisco Bay and the Santa Clara Valley, was California's "first lady" when her husband, Luis Antonio Arguello (1784–1830), was California's first governor under Mexican rule. The Arguello family's vast Rancho de las Pulgas covered most of the area that is today's San Mateo County. (Courtesy Dave Monley Photography.)

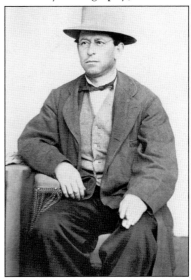

SOLEDAD ORTEGA AND JOSE RAMON ARGUELLO. Jose Ramon (1828–1876), the son of Luis Antonio and Soledad Ortega y Lopez Arguello (1797–1874), was born September 8, 1828, at the San Francisco Presidio. Educated in Monterey, Jose Ramon went into the mercantile business in Mexico City. In 1846, he returned to California to care for family interests on their Rancho de las Pulgas. Soledad and her two sons came to Santa Clara around 1857 and both had beautiful homes built in Santa Clara. (Courtesy Warburton family.)

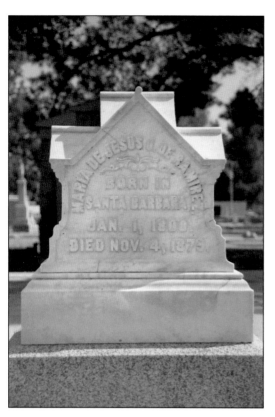

MARIA DE JESUS RAMARIZ MONUMENT.
Maria de Jesus de Ortega Ramariz
(1800–1879) was the younger sister of
Soledad Ortega Arguello and is buried in
the Arguello family plot. Maria was born
in Santa Barbara on January 1, 1800, and
died November 4, 1879. (Courtesy Dave
Monley Photography.)

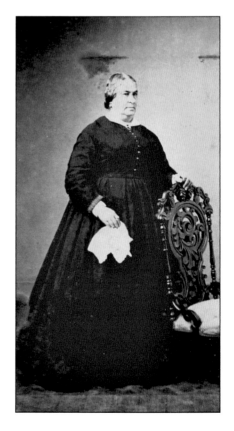

MARIA DE JESUS DE ORTEGA RAMARIZ. Maria
de Jesus Ortega was the daughter of Jose Maria
Ortega and Maria Francisco Lopez. She married
sub-lieutenant Jose Ramariz y Malpuarto on October
22, 1823. Ramariz was from Tacubaya, Mexico, and
the son of Andres Ramariz and Maria Manuela
Malpuarto. There are no children listed in mission
baptism files. (Courtesy Warburton family.)

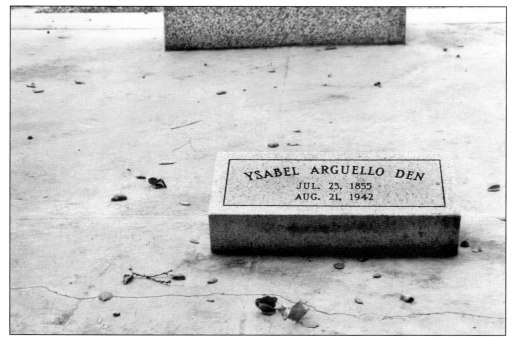

ISABEL ARGUELLO DEN MARKER. In 1855, Isabel Arguello Den (1855–1942), the daughter of Jose Ramon and Isabel Alviso Arguello, was born in Santa Clara. Isabel's mother died when she was only five years old. In 1874, Isabel was one of four girls who graduated from the College of Notre Dame in San Jose. She married Nicholas Den (1848–1901) at Mission Santa Barbara about 1878. (Courtesy Dave Monley Photography.)

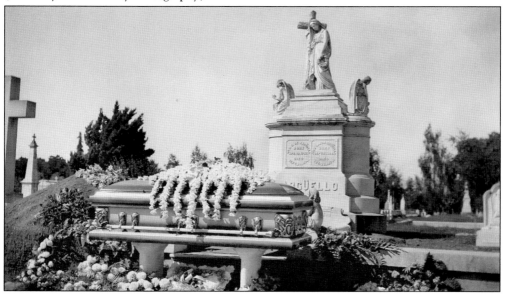

ISABEL ARGUELLO DEN FUNERAL. Isabel grew up in the beautiful Jose Ramon Arguello family home on the northwest corner of Washington and Santa Clara Streets. Her husband Nicholas died in 1901, but Isabel lived until 1942. Her flower-covered casket awaits burial in the Arguello plot in the Santa Clara Mission Cemetery. The trees have grown greatly in the intervening years since 1942. (Courtesy Warburton family.)

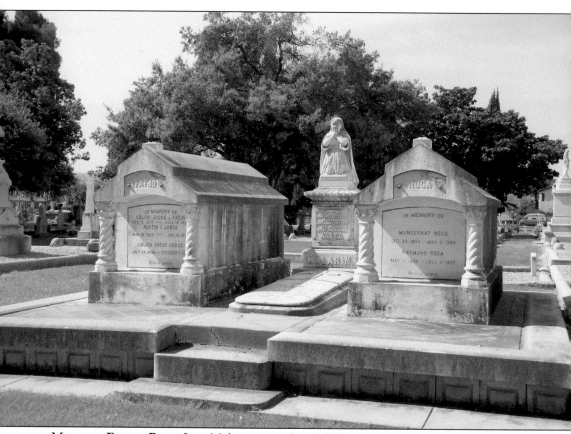

MALARIN FAMILY PLOT. Juan Malarin arrived in California in 1820, and in 1824, at Monterey, he married Josefa Estrada. The Malarins sent their son Mariano to study at Fort Vancouver, and he later attended college in Lima, Peru. Upon the death of his father in 1849, Mariano, being the eldest son, was obligated to leave Lima at 22 years of age and return to Monterey, California. (Courtesy Dave Monley Photography.)

MARIANO MALARIN MARKER. In California, Mariano (1827–1895) served in various civic positions, including that of judge and supervisor. He was elected a member of the California State Assembly in 1859 and reelected in 1860. Mariano married Isidora Pacheco in 1859. Mariano and Isidora moved to Santa Clara in the mid-1860s and built a new house at the southeast corner of Washington and Santa Clara Streets, near the homes of their relatives the Fatjos and Arguellos. (Courtesy Dave Monley Photography.)

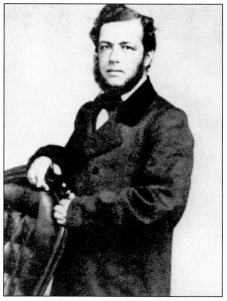

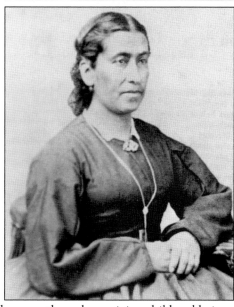

MARIANO AND ISIDORA PACHECO MALARIN. Isidora was the only surviving child and heiress of Francisco Perez Pacheco who owned enormous landholdings containing over 150,000 acres, including Rancho San Luis Gonzaga and the area of Pacheco Pass. The Malarins had two daughters: Paula who married Luis Fatjo, in Barcelona in 1880 and Mariana who married Dr. Ramon Roca. When Isidora died in 1892, she was the last of the Pachecos to be buried in the family crypt in San Carlos Cathedral in Monterey. (Courtesy California History Center, De Anza College, Cupertino.)

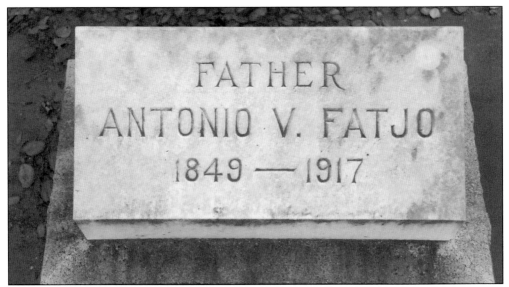

ANTONIO V. FATJO MARKER. Antonio V. Fatjo (1849–1917), the eldest son of Antonio and Mariana Fatjo, grew up in Santa Clara and went into the family dry goods business. He was instrumental in the reorganization of the Santa Clara Valley Bank and later organized the Mission Bank with his son Robert A. Fatjo. Antonio V. and his brother John bought back the family store on Franklin Street. Thereafter, the store was known as John Fatjo and Son. (Courtesy Dave Monley Photography.)

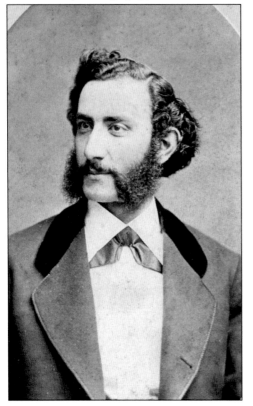

ANTONIO V. FATJO. Antonio V. married a widow, Refugio Malarin Spence, whose great-grandfather was Jose Dario Arguello, one of the last Spanish governors of California. Her first husband had been David Spence, a member of a wealthy, prominent Monterey County family, with whom she had six children. (Courtesy Warburton family.)

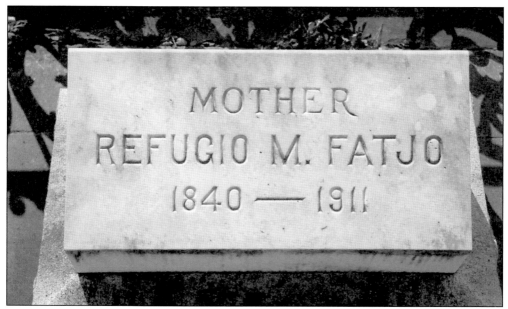

REFUGIO MALARIN FATJO MARKER. Refugio Fatjo (1840–1911) is buried in a plot with her husband Antonio V. and their daughters Amelia (1874–1875) and Delfina (1859–1968). Their plot is adjacent to the Arguello and Malarin plots. Just as the Arguello, Fatjo, and Malarin families lived near each other in life, their final resting places are also in close proximity. (Courtesy Dave Monley Photography.)

REFUGIO MALARIN FATJO. Refugio Malarin Spence married Antonio V. Fatjo. They had three children: Robert A. (1876–1960), Eugene, and Delfina (1859–1968). Delfina, who never married, lived most of her adult life in her residence at 646 Washington in Santa Clara. Heartbroken on the sudden death of her mother, Delfina invited her Aunt Clorinda, an English teacher in Panama, to come and live with her. The two ladies lived out their lives together. (Courtesy California History Center, De Anza College, Cupertino.)

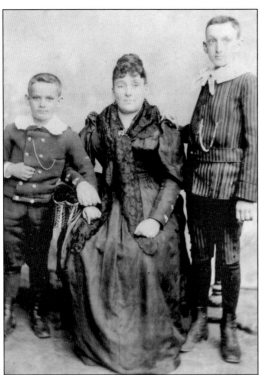

REFUGIO MALARIN FATJO AND SONS. Refugio is shown here with her sons Eugene and Robert A. Eugene became a banker and married Katherine Miner. The couple had one child, also named Katherine, who graduated from Dominican College in San Rafael. Robert A. was educated at Santa Clara University. He entered the real estate profession in the business office of Fatjo and Lovell at a time when his father was involved in banking. (Courtesy California History Center, De Anza College, Cupertino.)

FATJO HOUSE. Antonio V. and Refugio built a home at the southwest corner of Washington and Santa Clara Streets. To their north, on the site now occupied by St. Clare's School, was the three-story home of their cousin, Jose Ramon Arguello and his wife, Isabel. On the east side of Washington Street was the prominent home of Mariano Malarin. (Courtesy of California History Center, De Anza College, Cupertino.)

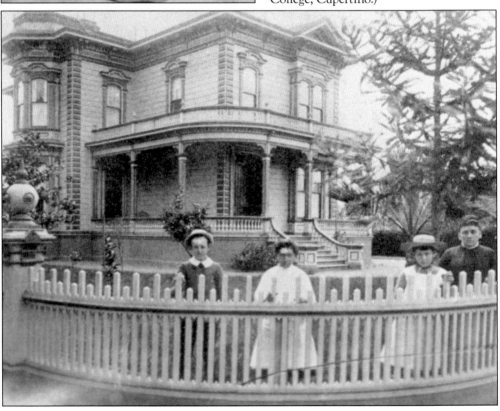

TIBURCIO VASQUEZ MONUMENT. The unusual placement of Vasquez's grave marker led some to surmise that the bandit had been buried at an opposing angle to the surrounding graves. Actually Tiburcio (1855–1875) was buried at the turn of an old cemetery road. For years a single palm tree marked his final resting place. Around 1930, the cemetery marked the site with a granite marker. The cactus growing on either side of the marker is a recent addition. (Courtesy Dave Monley Photography.)

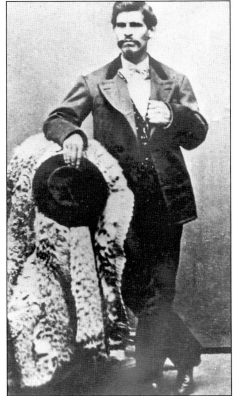

TIBURCIO VASQUEZ. Famed as California's "Robin Hood" bandit, Monterey born Tiburcio is often mistaken for the mythical bandit Joaquin Murrieta. Captured after a bold daylight robbery of a Tres Pinos store in which three onlookers were killed, Tiburcio was publicly executed by hanging in San Jose on March 19, 1875. (Courtesy Santa Clara Historic Archives.)

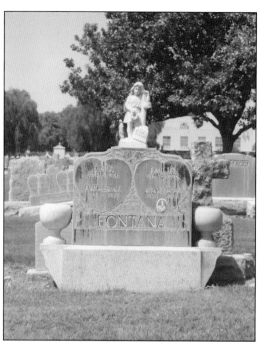

SISTO AND CATHERINE FONTANA MONUMENT. Sisto (1882–1958) and Catherine (1886–1962) Rossi were both natives of Genoa, Italy. They are both buried at Santa Clara Mission Cemetery. Also buried in the same plot are their children Angelina (1920–1934) and Emilio (1916–1975). Emilio was murdered, along with his wife, Verna, on an isolated stretch of Baja California's trans-peninsular freeway on January 25, 1975. Their murder was never solved by the Mexican or Santa Clara Police authorities. (Courtesy Dave Monley Photography.)

SISTO AND CATHERINE FONTANA'S WEDDING. Sisto Fontana married Catherine Rossi in Genoa, Italy. They came to Santa Clara about 1918 and lived at 1293 Lewis Street. He established Santa Clara Scavenger Company which later became Mission Trail Garbage Company. People still remember Mr. Fontana picking up the newspaper wrapped garbage with his horse and wagon for 50¢ a month. The garbage was dumped in an area of the present day Mission City Memorial Park cemetery. (Courtesy Bacosa Photography and Emma [Fontana] Kaliterna.)

FONTANA FAMILY. Pictured, from left to right, are Angelina (1920–1934); Emilio (1916–1975) who became the owner of Mission Trail Garbage Company after his father retired; mother Catherine (1886–1962) holding John who was born in 1924; and Emma, born in 1918, who married Milton (Mickey) Kaliterna. Emma has owned and operated Emma's Coiffures for 64 years. She has been actively involved in the community for many years. (Courtesy Emma [Fontana] Kaliterna.)

FONTANA FAMILY. Sisto and Catherine's son John and Delphine Fernandez were married in 1952 by Rev. W. J. Schmidt, S.J. at St. Clare's Church in Santa Clara. John had graduated from San Jose State College as a police major. He served with the army in Korea, and was employed in the Santa Clara County sheriff's office. Pictured, from left to right, are Mary and Emilio Fontana; Catherine Fontana, John Fontana with daughter Stephanie; and Sisto Fontana. (Courtesy Emma [Fontana] Kaliterna.)

FRANCIS AND ANN BLAKE MONUMENT. Francis "Frank" (1865–1934), son of Frank Blake and Catherine McCoy, was born in 1865 in Grass Valley. Ann (1870–1946), Frank's wife, was also born in the gold country. The family went to live in Virginia City, Nevada, where Frank worked as a copy boy at the *Territorial Enterprise* newspaper. (Courtesy Dave Monley Photography.)

FRANK AND ANN BLAKE. Frank Blake married Ann Shaughnessy and they had three children: Frank Jr. (1890–1942) who married Alice Roscoe (1896–1965); Lucile who married Thomas Eastman; and Leslie (1895–1979) who married Cecelia Cunningham (1896–1976). The children were all born in Virginia City. (Courtesy Margot [Blake] Warburton.)

TERRITORIAL PRESS OFFICE. In this c. 1900 photograph, Frank Blake Sr. is the man at the far right rear and his son Leslie is the boy sitting on the counter to the left of the stove. Samuel Clemens, otherwise known as Mark Twain, was editor of the *Territorial Enterprise* in 1863. Mark Twain is the author of the classics *Huckleberry Finn*, *Tom Sawyer*, and *The Celebrated Jumping Frog of Calaveras County*. (Courtesy Margot [Blake] Warburton.)

FRANK, LUCILE, AND LESLIE BLAKE. The children of Frank Sr. and Ann (Shaughnessy) Blake, standing arm in arm on the sidewalk in Virginia City, are, from left to right, Leslie (1895–1979), Lucile, and Frank Jr. (1890–1942). (Courtesy Margot [Blake] Warburton.)

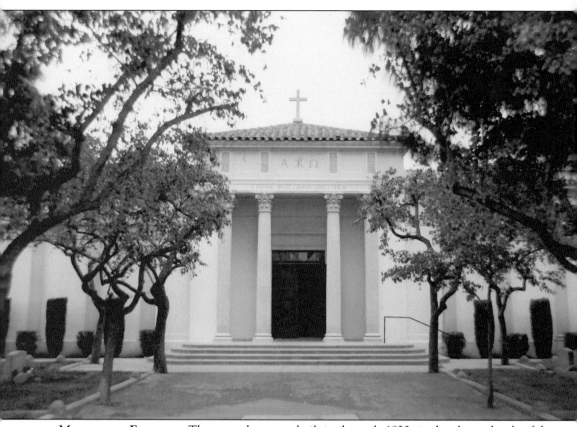

Mausoleum Exterior. The mausoleum was built in the early 1930s in the classical style of the day. Note the classic columns topped with Ionic capitals. This classical style draws its inspiration from the temples of Greece and Rome. (Courtesy Dave Monley Photography.)

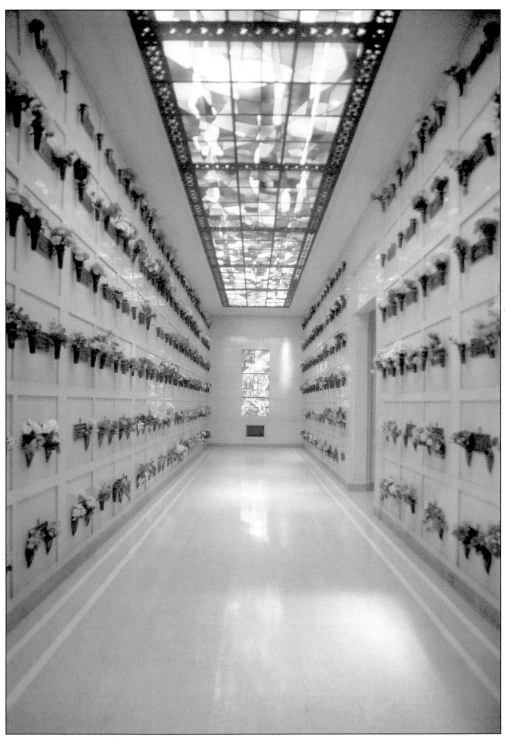

MAUSOLEUM INTERIOR. The marble crypts and floors are highlighted by the stained-glass windows, skylights, and the bright and varied flowers adorning the crypts. (Courtesy Dave Monley Photography.)

ROBERT A. AND JULIA G. (1902–1990) FATJO CRYPT. Robert A. Fatjo, the son of Antonio V. and Refugio Malarin Fatjo, was born in Santa Clara and went to school at St. Joseph's School, commonly referred to as "the brick school," where St. Clare's Church stands today. In 1910, he helped with the organization of the Mission Bank and served as president until 1917, when it was sold to Bank of Italy. Robert became manager of the Santa Clara branch. (Courtesy Dave Monley Photography.)

TERESA F. FATJO CRYPT. Robert A. Fatjo married Teresa Farry, the daughter of Patrick and Mary Farry. Patrick Farry was born in Ireland. During the great potato famine, he migrated to New York and later moved to California and Santa Clara. The Farry home still stands at 824 Washington Street. (Courtesy Dave Monley Photography.)

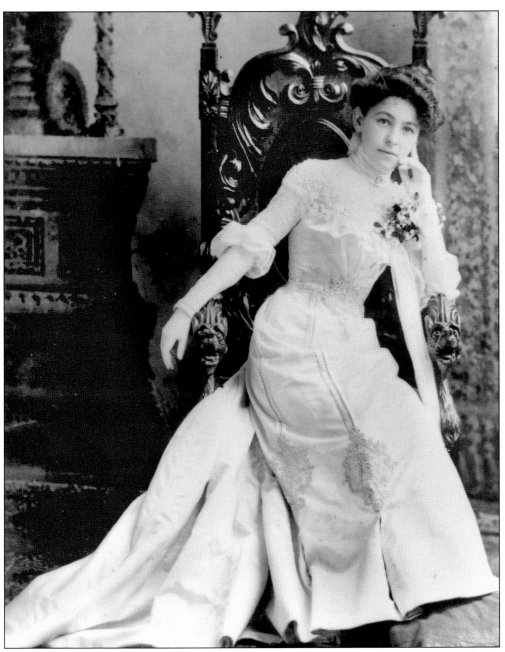

Teresa Farry Fatjo Wedding Dress. In 1902, Teresa Farry, shown here in her magnificent wedding dress, married Robert A. Fatjo. Following their marriage, Robert A. and Teresa moved into a home at Washington and Liberty Streets where both of their children, Mary Teresa (1905) and Robert J. (1907), were born. In 1911, the family moved into a new Spanish-Revival style home at 616 Washington Street. Teresa passed away in 1927 and some years after her death, Robert married Julia Golden. (Courtesy California History Center, De Anza College, Cupertino.)

GARDEN CRYPTS COURTYARD. In 1961, Santa Clara Mission Cemetery expended their cemetery facilities by adding the Garden Crypts. There are several courtyards within the facility. This courtyard with its trees, grass, and statue provides a quiet and serene atmosphere for people visiting the resting places of those buried here. (Courtesy Dave Monley Photography.)

LESLIE J. AND CECELIA BLAKE CRYPT. Leslie (1895–1979), the son of Frank and Ann Blake, was born in Virginia City, Nevada, in 1895. Cecelia (1896–1976), the daughter of James and Lillian Cunningham, was born in Los Angeles, California, in 1896. Leslie and Cecelia were married February 27, 1921, in Reno, Nevada. The Blake's had two daughters: Helen, born in 1925, married Richard Christy in 1948, and Marguerite Leslie (Margot), born in 1929, married Robert Warburton in 1950. (Courtesy Margot [Blake] Warburton.)

Leslie and Cecelia Blake 50th Anniversary. In 1927, Leslie Blake and his brother Frank, members of one of the West's pioneer newspaper families, bought the *Santa Clara Journal*. Leslie had previously owned the *Carson City Daily Appeal* for five years before coming to Santa Clara. In 1947, Leslie sold the *Journal* to George Payne. Leslie and Cecelia had a long and happy married life and in 1971 celebrated their 50th wedding anniversary. (Courtesy Margot [Blake] Warburton.)

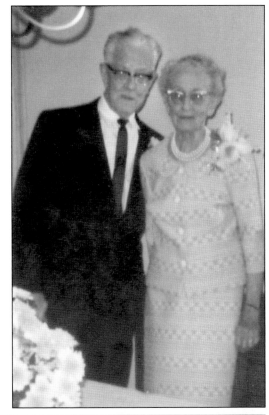

Blake's Stationary Store. In 1951, Leslie Blake, veteran Santa Clara newspaperman and printer and former owner of the weekly *Santa Clara Journal*, opened a stationery store and print shop at 1026 Franklin Street. Leslie sold the business in 1960 to his son-in-law Robert (Bob) Warburton. After the Urban Renewal Project razed eight square blocks of the downtown, Bob relocated to the business to Franklin Mall. (Courtesy Margot [Blake] Warburton.)

JOHN AND JOSEPHINE SANCHEZ MONUMENT. Pablo and Maria Tujillo Sanchez and their children, John and Isabel, were from the Province of Malaga on the south coast of Spain. In 1907, the family responded to the Don Carlos Corvetto advertising poster (on page 109) and shipped off to Hawaii. Not long after their arrival, Maria died on the island of Kauai. Pablo and his children then moved to Hilo where Pablo married Juana Rodrigues. (Courtesy Dave Monley Photography.)

JOHN AND JOSEPHINE SANCHEZ. John Sanchez (1898–1985) and Josephine Callejon (1902–2001) had known each other in Hawaii. They reacquainted in Santa Clara and married in 1921 at Mission Santa Clara. They had two children: Mary, born in 1922, and John Jr., born in 1924. John Sr. worked at Rosenberg Brothers packing company for 27 years until he retired in 1963. Josephine also worked at Rosenberg for 26 years. When it went out of business, she worked at Mayfair Packing until she retired in 1965. (Courtesy Bacosa Photography and Mary [Sanchez] Gomez.)

(This is a copy of a poster distributed in Spain shortly after the turn of the century to attract people to Hawaii) —Josephine Madrid Collection

EMIGRACION CON PASAJE GRATUITO AL ESTADO
DE HAWAI,
(ESTADOS-UNIDOS DE AMÉRICA)
Descripción de las Islas Haway, según el célebre viajero M. C. de Variony

••......Es punto menos que imposible hacer comprender, á quien no los ha disfrutado, los incomparables atractivos del clima de las Islas de Hawai. Una temperatura constantemente igual, que todo lo mas varia diez grados, y que casi siempre está á 30° centígrados; un cielo purísimo, apenas velado de vez en cuando por frescas nubecillas y lluvias oportunas; una naturaleza alegre y ozana, admirablemente iluminada por un sol radiante, constituyen el atractivo mas poderoso para atraer al extranjero y obligarle á prolongar su permanencia en aquellas Islas. Las tempestades son muy raras allí, tan raras como los huracanes, que suelen ser el azote de los países intertropicales; las noches, sobre todo, son sumamente apacibles, y cuando brilla la luna, envolviendo las campiñas en los suaves y misteriosos efluvios de sus rayos, cualquiera se creería víctima de una ilusión encantadora. Es tan pura y despejada la atmósfera que á media noche se puede leer á la claridad combinada de la luz y las estrellas. En ninguna parte se extiende la vía láctea con tanto esplendor y majestad como allí; las constelaciones invisibles en Europa, iluminan el espacio y brillan como deslumbradoras perlas: el mar despliega en la costa sus oleadas fosforescentes y mece sus plácidos ensueños con lento y monótono movimiento .

Los emigrantes Españoles que quieran acojerse á las concesiones y beneficios que ofrecen las Leyes de Inmigración y Colonización del Estado de HAWAI, obtienen pasage gratuito desde Málaga para dicho Estado, en magníficos Vapores de marcha rápida, de más de 12.000 toneladas, con comida, durante el viaje, á la Española, condimentada por cocineros embarcados expresamente para ello.

El Gobierno de dicho Estados, bajo cuya garantía se efectúa la emigración, ofrece, á los VERDADEROS AGRICULTORES un porvenir halagüeño, cuyas ventajas son las siguientes:

Los varones cabeza de familia

20 duros americanos oro, al mes, durante el primer año de trabajo.

21 duros americanos oro, al mes, durante el segundo año.

22 duros americanos oro, al mes, durante el tercer año.

Las mujeres, sus esposas 12 duros oro al mes.

Los demás individuos de su familia que sean mayores de 15 años, 15 duros mensuales, si son varones y 10 duros si son hembras.

Desde que desembarquen, se les facilita una magnífica casa-vivienda (que vale más de 500 pesos oro) agua y lumbre y escuela gratuita, á los que es obligatorio asistir á ella.

Y á los **tres** años de trabajo, con buena conducta y en los que hayan demostrado que son buenos Labradores (y especialmente para el cultivo de la caña de azúcar), se les cede gratuitamente y en propiedad absoluta y sin gravámen alguno, la casa donde estén viviendo y además una fanega de tierra.

Condiciones que deben reunir los emigrantes

Es condición indispensable que los emigrantes sean **agricultores** que gozen de buena salud, no padezcan de la vista, que no tengan defectos físicos y que formen precisamente **familias** cuya constitución puede ser, como sigue:

1.° Marido y mujer sin hijos, no teniendo el marido **más de 45 años**, ni la mujer **más de 40**.
2.° Marido y mujer con hijos, no pudiendo los jefes tener más de 45 años, con tal que haya en la familia un hombre útil de **17 á 45 años.**
3.° Viudo ó viuda con hijos, teniendo siempre un hombre útil **mayor de 17 años y menor de 45 años.**
4.° Hombre casado no llevando la mujer, pero si llevando hijos con tal que haya siempre un hombre útil de **17 á 45 años.**
5.° Mujer casada no llevando su marido, pero si llevando hijos con tal que haya uno útil de **17 á 45 años.**

Podrán ir como agregados á las familias antes expresadas, todos los parientes, carnales y políticos, menores de 40 años. Las personas mayores de 45 años no gozan de pasage gratuito: estas tienen que pagarse el pasage que cuesta Pesetas 400.

Documentos que necesitan presentar las familias que deseen emigrar

1.° Cédula personal para todos los mayores de 14 años.
2.° Los varones y mujeres solteras, hasta la edad de 23 años, una autorización de sus padres ó tutores, otorgada ante Notario ó ante el Alcalde del pueblo de su vecindad. Este documento no es necesario cuando vayan en compañía de sus padres, pero en todo caso las mujeres solteras han de presentar un certificado que acredite su estado de soltería.
3.° Partida de bautismo para todos los varones y mujeres solteros.
4.° Los varones de 15 á 40 años no pueden embarcar sin presentar un certificado que acredite haber consignado en la Caja de Depósito la suma de 1.500 pesetas á las resultas de la quinta, según previene la ley.
5.° Los varones de 20 á 40 años han de presentar la licencia absoluta si son licenciados definitivos. Los que pertenezcan á la reserva ó á la clase de reclutas disponibles han de presentar un permiso del Capitán General del distrito respectivo, autorizándoles para efectuar su embarque ó ausentarse de la Península. Este documento no puede tener más de 4 meses á contarse desde la fecha de su expedición.
6.° Las mujeres casadas que no vayan acompañadas de sus maridos han de presentar un permiso de éste, visado por la Alcaldía del pueblo de su vecindad ó por Notario, siendo en la Capital.
7.° Partida de casamiento para los matrimonios.
8.° Partida de viudedad para las viudas.
9.° Certificado de buena conducta expedido por la Alcaldía de su residencia con las señas personales, para todos los individuos mayores de 14 años.
10 Certificado de no estar procesado, expedido por el Juzgado del pueblo donde residan, para todos los mayores de 14 años, ó de la Audiencia siendo en la Capital.

DESCONFIAR DE LOS INTERMEDIARIOS
Para mayores detalles y presentación de documentos:
DON CARLOS CROVETTO, Encargado del Departamento de Revisión
CALLE DE RIOS ROSAS (antes Cañón) núm. 3.--Málaga

DON CARLOS CORVETTO POSTER. Advertising opportunities in the new world and Hawaii, this poster was circulated in Spain by Don Carlos Corvetto. The notice offered free passage to Hawaii and employment as agricultural workers, earning as much as 20 gold American dollars the first year and 21 the second year. Many families prominent in Santa Clara history, including the Callejon, Cano, Sanchez, Sapena, Toledo, and Vasquez families, were among the immigrants who availed themselves of the Corvetto offer. (Courtesy Bacosa Photography and Mary [Sanchez] Gomez.)

ANTONIO AND MARIA R. SAPENA MONUMENT. Antonio (1882–1962), the eldest son of Vicente Sapena and Theresa Pastore, was born November 28, 1882. After Vicente died from a gun accident, Antonio was sent to Madrid to be educated. He ran away to Barcelona, where he became a cabin boy on a merchant ship. In 1903, Antonio went to New York and then on to San Francisco where he meet and married Maria Rodriquez (1894–1975) in 1911. (Courtesy Dave Monley Photography.)

SAPENA FAMILY. Maria's father, Antonio Rodriquez, had died when she was quite young and her mother married a widower, Frank Cano, who had two sons. The Cano family went to Hawaii in 1907. After marrying and settling in Santa Clara, Antonio and Maria (seated at table) had five children. Standing here, from left to right, are Joseph (Joe), born in 1921, who taught in the Santa Clara School District for almost 25 years; Teresa (Sapena) Romero who was born in 1918 and worked in department store sales; Carmen Sapena, born in 1914, who worked at Pratt-Low Cannery for 31 years; Frank (1916–1989), who served as Santa Clara Police Chief for 25 years; and Anthony (Tony), born in 1912, who worked for the City of San Jose fire department for 30 years. (Courtesy Doris Sapena, Santa Clara Historic Archives.)

ALFONSO G. AND JOSEPHINE GIL VASQUEZ MONUMENT. On December 20, 1911, in Spain, Alfonso Garcia Vasquez, born in Esteponam Provincia of Malaga, Spain, on February 13, 1886, married Josephine Lopez Gil, born on February 8, 1892, in San Roque, Cadiz, Spain. The Vasquez family was another Santa Clara family who left Spain on February 1912 for jobs and opportunities in Hawaii. Alfonso's mother, Francisca Garcia Vasquez, migrated with them. (Courtesy Dave Monley Photography.)

ALFONSO, FRANCISCA, AND JOSEPHINE VASQUEZ. Alfonso worked at the sugar refinery in Peepekeo, near Hilo. After almost six years, they opted to come to California for better opportunities and settled in Santa Clara, in the area known as Spanish Town. Pictured here, from left to right, are Alfonso Garcia Vasquez (1886–1960), Francisca Garcia Vasquez (1874–1923), and Josephine Lopez Gil (1892–1985). (Courtesy Vasquez family.)

ALFONSO VASQUEZ FAMILY. The Vasquez family gathered in 1932 for this delightful picture, from left to right, are Mary, father Alfonso, Frances and Joe in front of her, mother Josephine holding Mercedes, Josephine, and Alfonso Jr. In 1935, their youngest son Frank was born. Alfonso was foreman at the Carpenter Ranch and Wright Ranch where he hired the men needed for the fruit harvest. (Courtesy Vasquez family.)

VASQUEZ SIBLINGS. All of the Vasquez children graduated from Santa Clara High School and most went to Heald College for business training. Each has contributed to the history of the community of Santa Clara. Pictured about 2000, from left to right, are (first row) Frances (Vasquez) Callarrudo, Josephine (Vasquez) Mano, and Mercedes (Vasquez) Wells; (second row) Alfonso Jr., Frank, and Joe. (Courtesy Vasquez family.)

POLICE CHIEF FRANK VASQUEZ. Frank Vasquez attended West Valley College and then Santa Clara University where he earned a degree in Municipal Management. Frank joined the Santa Clara Police Department and worked his way up through the ranks. In 1975, Frank was appointed assistant chief of police and then chief on January 12, 1988, to fill the unexpired term of Manny Ferguson. Elected in November 1988 and November 1992, he served until February 11, 1994, retiring due to family illness. (Courtesy Frank Vasquez.)

FRANK VASQUEZ FAMILY. Frank Vasquez married Rosaine Blossom. Their family, from left to right, includes daughter Rosaine (1954–2000), Frank, wife Rosaine, son Rick, and daughter Renee. Since retiring, Frank has remained involved in the community, most particularly with the Rotary Club of Santa Clara. (Courtesy Frank Vasquez.)

ST. CLARE CHAPEL AND MAUSOLEUM. St. Clare Chapel was built in 1985 as part of Santa Clara Mission Cemetery's program to expand and update the 60-acre facility. Several courtyards add to the beauty of the Spanish Revival–style structure. (Courtesy Dave Monley Photography.)

FRANK AND DORIS SAPENA CRYPT. Frank (1916–1989), the third son of Antonio and Maria Sapena, was born in 1916. During World War II, he joined the Coast Guard and participated in the invasion of Dutch Guiana, where his ship was torpedoed and Frank was one of 87 rescued by Army amphibious vehicles. He was hospitalized for 11 months at a naval hospital in Pennsylvania. While hospitalized, Frank met Doris Brett (1927–2000) whom he later married. (Courtesy Dave Monley Photography.)

DETECTIVE FRANK SAPENA. The Santa Clara Police Department expanded in the late 1940s and Frank Sapena was one of the new officers hired in December 1947. He moved up through the ranks, serving as traffic officer in 1949, a detective in 1950, juvenile officer in 1952, and as inspector of detectives in 1953. (Courtesy Doris Sapena, Santa Clara Historic Archives.)

POLICE CHIEF FRANK SAPENA. Frank took a leave of absence in 1955 to run for chief of police on an eight-point program to reform and improve the department. He was elected and reelected, serving as chief for 20 of the 28 years he was with the department. Under his administration, the police department grew from 21 to 153 men and women. Frank is shown at a victory celebration with his longtime supporter, Emma (Fontana) Kaliterna. (Courtesy Doris Sapena, Santa Clara Historic Archives.)

EMIL R. AND NEOLA A. BUCHSER MONUMENT. Emil R. Buchser Sr. (1895–1969) was born to immigrant parents in San Jose on June 8, 1895. His mother came from Germany and his father from Switzerland. Young Emil did not speak English and could not enter school until he was proficient the language. At the age of eight, Emil entered Willow Glen Elementary School. With starting school late and interruptions in his schooling, he finally graduated from high school at the age of 23. (Courtesy Dave Monley Photography.)

EMIL R. BUCHSER RETIREMENT DINNER. Emil married Neola Merchant (1902–1981) in 1930. Neola worked as a secretary in the president's office at San Jose State College. Emil eventually completed 40 years of public service, retiring June 30, 1961. His service began in 1920 as a teacher at Fremont School and then as principal of the Santa Clara Intermediate School for 18 years. Shown at his retirement dinner, from left to right, are Nadine (Bollinger) McCoy, Emil's mother, Emil, and wife Neola. (Courtesy Buchser family.)

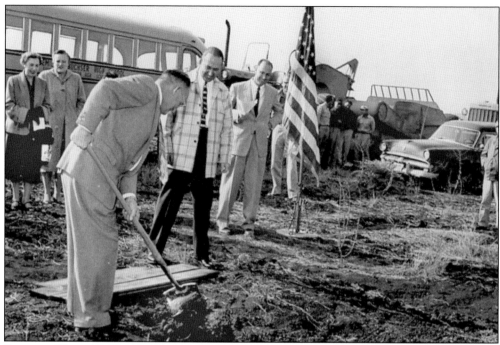

BUCHSER HIGH SCHOOL GROUNDBREAKING. Buchser High School, named for Emil R. Buchser, opened in September 1959 at 3000 Benton Street. Shown at the groundbreaking, from left to right, are: school board member Marian A. Peterson, counselor Jana Shaw, superintendent Emil R. Buchser (with shovel), contractor Bill Nicholson (in plaid jacket), and deputy superintendent Wendell Huxtable. (Courtesy Buchser family.)

EMIL R. BUCHSER JR. AND ROBERT E. BUCHSER. Two sons, Emil R. Jr. (Rudy) and Robert E. (Bob), were born to the Buchsers, and they both followed their father into education. Rudy taught industrial arts at Wilson Intermediate School and then served as the first principal at Wilcox High, until assuming the position of director at Wilson Adult Education Center. Bob taught at Santa Clara High School and served as principal of Valley Continuation High School. (Courtesy Buchser family.)

LOUIS AND LUCY V. GOYENA MARKER. Like many Santa Clarans, the family of Louis (Louie) Goyena came from Spain. Louie was born March 13, 1913, in Riverside, California. The parents of Lucy Lorente Vasquez also came from Spain to Hawaii and then to California. Lucy was born August 8, 1916, in Flower, California. Lucy (1916–1996) and Louis (1913–1966) were married November 30, 1937, in Selma, California. (Courtesy Peg [Goyena] Horrillo.)

LOUIS AND LUCY GOYENA AND DAUGHTERS. Louie and Lucy moved to Santa Clara in 1948 and purchased a home at 2035 Main Street. Louie was a self-employed truck driver and Lucy worked seasonally in the local canneries. They had two daughters, Peggy (left) and Priscilla, shown in 1948 on their Dad's truck. Both girls went to the local schools and graduated from Santa Clara High School. (Courtesy Peg [Goyena] Horrillo.)

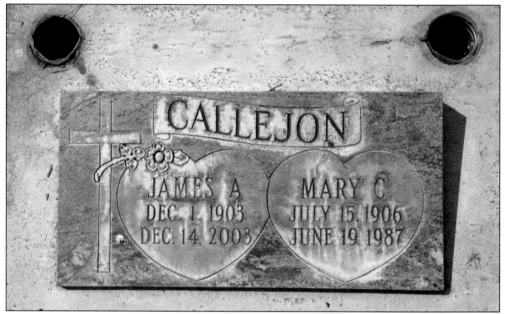

JAMES A. AND MARY C. CALLEJON MARKER. In 1911, Antonio and Maria Lopez Callejon and their four children migrated from Spain to Hawaii. The Callejon family lived near Hilo for about five years, working in the sugar cane fields. The family moved to California in 1917 and stayed in San Francisco for a brief time before settling permanently in Santa Clara. (Courtesy Dave Monley Photography.)

JAMES AND MARY CALLEJON'S 50TH ANNIVERSARY. On November 1, 1925, James (1903–2003) married Mary Bronk (1906–1987). James raised cherries and walnuts as a rancher in San Jose on Capital Avenue in the Berryessa District. James and Mary had a long married life and celebrated their 50th wedding anniversary in 1975. (Courtesy Don Callejon.)

CALLEJON CHILDREN IN HILO. The children of Antonio and Maria Lopez Callejon included Josephine, the oldest, born in 1902; James in 1903; Catherine, born in 1906; and little Mary, who died shortly after arriving in Hawaii. Another daughter was born in Hilo and was named Mary in memory of little Mary. The children all attended school in Hilo. Pictured in 1916 in Hilo are the second Mary (in chair) and, from left to right, Josephine, Catherine, and James. (Courtesy Don Callejon.)

ADULT CALLEJON SIBLINGS. The long-lived Callejon children are (first row) Josephine (1902–2001) who married John Sanchez (1898–1985), and James (1903–2003) who married Mary Bronk (1906–1993); (second row) Mary Callejon, who married John Hidalgo; and Catherine Callejon (1905–1993) who married Anthony (Tony) Toledo (1901–1980). (Courtesy Bacosa Photography and Mary [Sanchez] Gomez.)

ANTHONY R. AND CATHERINE C. TOLEDO MARKER. In 1901, Anthony Rodriquez Toledo (1901–1980), the oldest son of Antonio and Margarita Toledo, was born in Granada, Spain. After repaying the costs of their voyage to Hawaii, Antonio moved his family to San Francisco in 1913 and then to Santa Clara in 1918. Tony worked for the Brown family in their pear orchards. (Courtesy Dave Monley Photography.)

ANTHONY AND CATHERINE TOLEDO'S 50TH ANNIVERSARY. Tony met Catherine Callejon (1905–1993), who had been born in 1905 in Estepona, Malaga, Spain. The Callejon family had also migrated to Hawaii and then to Santa Clara. Tony and Catherine married in 1926 at the Santa Clara Mission and lived at 1738 Harrison for 29 years. Their son, Anthony Jr., was born in 1927, and their daughter, Margie, in 1937. In 1976, they celebrated their golden wedding anniversary. (Courtesy Margie [Toledo] Del Prete.)

TOLEDO'S MARKET. Tony Toledo became interested in the grocery business. For a while, he worked for John Fatjo and the Sallows family store on Franklin Street. The Red and White Market opened on August 22, 1919. Tony went to work there in 1926 and when Frank Sallows died in 1928, Tony bought the business and operated it under the name of Toledo's Red and White Market until 1963 when it was demolished for urban renewal. (Courtesy Margot Warburton.)

SANTA CLARA CITY HALL. Tony's political career began in May 1943 when he was appointed to the town's board of trustees. He was elected the following year and served until 1949 when elected to the board of Freeholders, which prepared a new charter of the city and set the basis for today's Santa Clara government. Tony was mayor in 1950–1951, elected again to the council from 1951 to 1958, and elected mayor again in 1958–1959. (Courtesy Santa Clara Historic Archives.)

WALTER W. WADE MARKER. Born on February 21, 1905, in San Jose, Walter William Wade (1905–1993) was a descendent of Ignacio Alviso, majordomo of the Santa Clara Mission, and Charles Wade, one of the unwilling 1849 discoverers of Death Valley. He went to work in Santa Clara at the Fernish Drugstore, where, in 1932, he meet Clara Gorman. Romance blossomed and the two were married in 1934 at St. Clare's Church. On February 3, 2005, Clara celebrated her 100th birthday. (Courtesy Dave Monley Photography.)

WADE'S MISSION PHARMACY. In 1927, Walter Wade went to work at Ben Fernish's drugstore. In 1938, the Fernish family sold the business to Walter, who had to find a new location in 1944 and moved into the Odd Fellows building on the southwest corner of Franklin and Washington Streets. Wade's Mission Pharmacy operated in that location until urban renewal forced him out. Walter then relocated to the two-square-block Franklin Mall development. (Courtesy Santa Clara Historic Archives.)

JOSEPH SR. AND MINNIE NAVARRO MONUMENT. Joseph Navarro (1892–1974) came from Seville, Spain, and his wife, Minnie Sanchez (1896–1974), was from Granada, Spain. They both settled with their families in Santa Clara. Joseph and Minnie meet in Santa Clara and romance followed. (Courtesy Dave Monley Photography.)

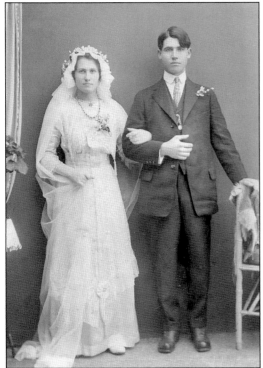

MINNIE SANCHEZ AND JOSEPH NAVARRO WEDDING. Minnie Sanchez, the daughter of Jose and Rosario (Castro) Sanchez, married Joseph Navarro on Christmas Day in 1914 at the Santa Clara Mission. The Navarro's had one son and four daughters that were raised in Santa Clara and went to Santa Clara schools. (Courtesy Rose [Navarro] Penner and Isabel [Navarro] Steffan.)

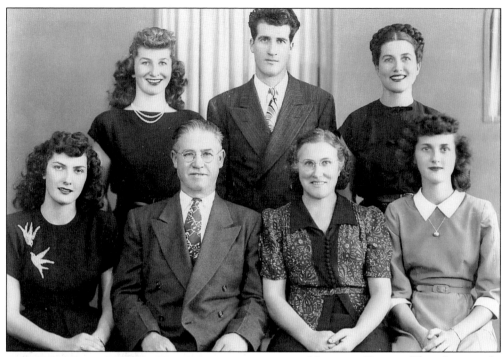

Navarro Family. This photograph of the Navarro family was taken in 1947. Pictured, from left to right, are (first row) Carmen (Navarro) Pasquinelli, father Joseph Navarro Sr., mother Minnie Navarro, and Isabel (Navarro) Steffan; (second row) Rose (Navarro) Penner, Joseph Navarro Jr., and Anne (Navarro) Seabury (1915–2000). (Courtesy Rose [Navarro] Penner and Isabel [Navarro] Steffan.)

Navarro Brother's Men's Wear Store. This is a picture of the first Navarro Brother's Men's Wear clothing store run by Joseph Navarro and his brother Antonio. It was located at the corner of Franklin and Washington Streets, in downtown Santa Clara. The brothers later moved across the street where the store remained in business until 1955. Shown in the picture are Antonio Navarro (at right) and two unknown customers. (Courtesy Rose [Navarro] Penner and Isabel [Navarro] Steffan.)

PABLO AND JUANA C. SANCHEZ MONUMENT. Pablo Sanchez (1867–1948) and Maria Trujillo had deep roots in the Province of Malaga on the south coast of Spain. Their son John was born in Malaga in 1898 and his sister Isabel two years later. In 1907, the family responded to the Corvetto advertising poster and shipped off to Hawaii. Not long after their arrival, Maria died on the island of Kauai. Pablo and his children then moved to Hilo. (Courtesy Dave Monley Photography.)

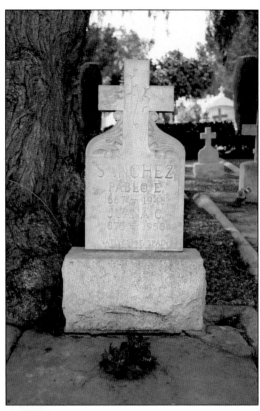

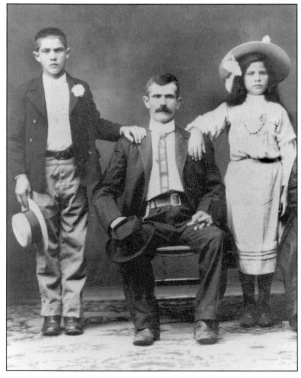

PABLO SANCHEZ AND CHILDREN. In Hilo, Pablo married Juana Rodrigues (1875–1950) and they remained in the Hilo area about 10 years. In 1918, Pablo heard of better opportunities on the mainland and he moved his family to California and settled in Santa Clara. During asparagus season, both Pablo and John worked for the Booth Company near Sacramento, where John became a foreman. John then worked at Rosenbger Brothers packing company for 27 years. (Courtesy Mary [Sanchez] Gomez and Michele [Gomez] Barosky.)

127

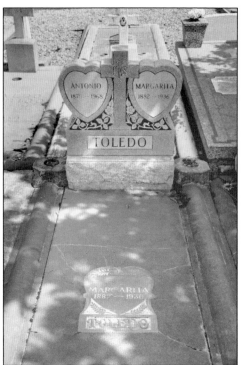

ANTONIO AND MARGARITA TOLEDO MONUMENT. Antonio Toledo (1875–1968) served with the Spanish cavalry during the Spanish-American War. After his stint in the military, he married Margarita Rodriguez (1882–1936). In 1901, their oldest son, Anthony (Tony), was born in Safaraja, Granada, Spain. Joseph, another son, was also born in Spain before the family migrated to Hawaii in 1907. More children were born in Hawaii including Manuel, Placido, John, Frank, Beatrice, and Mary. (Courtesy Dave Monley Photography.)

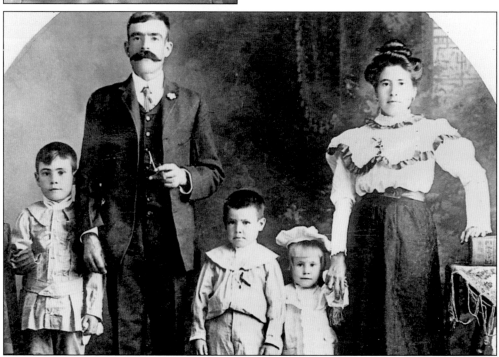

TOLEDO FAMILY. The Toledo family, from left to right, includes son Anthony (Tony), father Antonio Ruiz (1875–1968), son Joseph, son Manuel, and mother Margarita (1882–1936). This photograph was taken before the family migrated from Spain to Hawaii and then to Santa Clara. (Courtesy Margie [Toledo] Del Prete.)